AVANT-GARDE RUSSE

Translated by Jacques Gourgue and Shobha Raghuram

Published in the United States of America in 1986
by Universe Books
381 Park Avenue South, New York, N.Y. 10016

© 1986 by Fernand Hazan, Paris

86 87 88 89 90 / 10 9 8 7 6 5 4 3 2 1

Printed in France

Library of Congress Cataloging in Publication Data

Nakov, Andrei
Avant-garde russe.

Translation of: L'avant-garde russe.
Bibliography: p.
1. Suprematism in art. 2. Art, Russian. 3. Avant-garde (Aesthetics)—
Soviet Union—History—20th century. I. Title.
N6988.5.S9N3313 1986 709'.47 85-21010
ISBN 0-87663-884-1

Andrei Nakov

AVANT-GARDE RUSSE

UNIVERSE BOOKS
New York

FOREWORD

The term "avant-garde" being easily misleading, it appears to me necessary to specify the limits of the subject-matter. The richness of the artistic explosion that Russia experienced between 1896 and 1932 does not permit here the treatment of the subject in its entire range. Hence, I limited myself to explore only the evolution of plastic arts from the emergence of non-objective art in 1915 up to the end of 1921 when ideology and theoretical reflection assume the consequences in apparently opposed, but in fact dialectically interdependent directions. The advent of non-objective art had been preceded by a glorious symbolist period as well as by an extraordinary cubo-futurist flowering which could by itself constitute the subject of another book. One can say the same for the consequences of non-objective art in the realm of applied arts and more so in that of architecture; the remarkable invention of Russian architects would certainly merit a publication of its own.

The Russian avant-garde had its hours of glory in the theatre: it is enough to mention the names of Diaghilev, Tairov and Meyerhold with whom are associated the names of the great painters: Bakst, Larionov, Exter, Vesnin and Popova. The revolution in theatre equals that of the plastic arts, but due to lack of space it is treated sparsely in the pages which follow.

Modern art having abolished the artisanal limitation of the pictorial practice, what followed was an expansion of plastic creation into the domains of other arts and towards that of pure theory. The latter is so important that to understand the impact of new concepts, elaborated by non-objective art, it would have been necessary to study their interference with those of linguistics and semiology, exploration which is unfortunately not possible in the brief introduction that this volume hopes to provide on the subject.

Last of all, the relationship between the artistic avant-garde and the October Revolution must be mentioned. Contrary to documentary evidence and to that of the simplest chronology of events, a certain "Marxist" critique likes to merge the two. Pursuing an ideological argumentation, it "deduces" immediately a non-existent relationship of cause and effect evidently to its own advantage. Non-objective art has its own evolution and it proclaimed its independence from the very beginning. The critic Victor Shklovski protested against this assimilation of art and politics: "The greatest political error of those who currently (in 1918) write on art appears to be an equation between the social revolution and the revolution in artistic forms that they are trying to impose.(...) Art has always been autonomous in relation to life and its colour has never reflected the colour of the flag raised over the citadel." This independence was inscribed in the new relationship that the cubo-futurist avant-garde instituted since the beginning of its evolution between the form and the content (Shklovski): "a new form produces a new content," a position which excludes an inspiration taken otherwise as from the proper material of the work.

The ideological discourse which was later grafted onto the non-objective forms reflected at a certain moment the difficulties of Malevich's contemporaries evolved in his wake. The politicizing of the artistic discourse from 1918 led very rapidly to the death of the avant-garde. If the artists of the constructivist/futurist movement welcomed with open arms the great revolutionary outburst of 1917, it is because they finally saw the insertion of art into daily life; they hoped to materialise their own artistic utopia.

PART ONE

For Ania, her cousins and her friends.

From zero to infinity: "the free flight of forms"

*"A painting is something constructed
according to its own laws and not some-
thing imitative."*
Shklovski, 1919

On 19th December 1915, Kasimir Malevich displayed in Petrograd thirty-nine "non-objective" works, including an ordinary "quadrilateral" representing a black square on white ground.[1] In a booklet entitled *From cubism and from futurism to suprematism*, the painter explained the sources of his creations, the motivations for his evolution as well as the meaning of these simple geometric forms, in which a new plastic order appeared. The (two-dimensional) plane forms of a single colour that filled the "suprematist constructions" were declared "autonomous, living" and without any relation to our real world. The creator of suprematism refused from now on the right for painting to "reflect the nooks and crannies of nature." He strongly emphasizes that "for the new plastic culture, things had evaporated like smoke. Art is moving towards the pictorial end of itself," he concluded. As of that moment on, painting cut the umbilical cord which had attached it earlier to the surrounding nature. It rejected illustration and psychological narrative in order to build the autonomous world of a new plastic art.

Thanks to the acquisition of this new freedom (the autonomy of abstract forms), the non-objective plastic asserted its supremacy (hence the term "suprematism") on ancient painting, "slave to an extra-pictorial world" (Malevich). Propelled into a new space and freed from old servitudes in relation to subjects (narration) and objects (realism of illustration), this new painting was compelled to lay down its own laws, to formulate an order which would apply only to itself. At first, this new order defined itself exclusively in relation to the physical being of the plastic work: the material and its direct properties (pure form, colour and texture - i.e. the specific

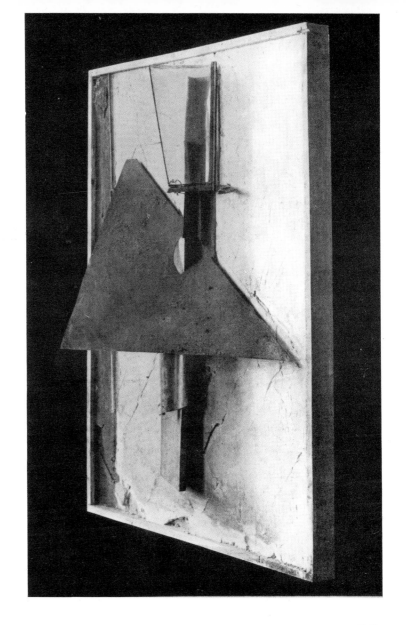

Tatlin
Synthetico-static composition
1914

materialisation of the plastic surface). That concentration of the non-objective plastic art over its material specificity led it to a degree of autonomy never before reached. Also it followed obligations: the new "plastic state" had to invent rules of conduct, a kind of autonomous legislation or a code of procedure, if one prefers. In the text quoted above, Malevich required that the new painter "know now what is happening in his paintings and why." At the same time, he gave indications concerning the new laws which should regulate that non-objective creation: "Art is the capacity to create a construction not derived from relationships between forms and colour, not founded on the aesthetic taste advocating the prettiness of the composition, but based *on the weight, the speed and the direction of the movement.*"

Malevich's suprematism constitutes the outcome of a brief but quite tumultuous evolution in Russian art that began in 1896. From that time onwards, the Russian exhibition halls opened widely their doors to the new currents of European art: impressionism, symbolism, fauvism and cubism. Colonies of Russian painters and sculptors, settled in Paris and Munich, established active contacts with the western milieu; the new ideas were diffused by a large number of art magazines which maintained a pace never before seen. Important collections of modern paintings were assembled in Moscow at the beginning of the twentieth century, to such an extent that if one wishes to be well acquainted with the work of Matisse or Picasso, a trip to Russia is mandatory, even today. By far the best among these collections is that of the Moscow businessman Sergeï Shchukin. Due to his cultural activities, this connoisseur was one of the most perspicacious initiators of the young Russian artistic generation to modern art.[2] Although remaining private until 1917 his collection was opened once a week to the public, with the owner serving as the guide.

Shchukin centred his attention on a few seminal figures of modern painting: Gauguin, Monet, Cézanne, Matisse and Picasso, thereby demonstrating an infallible judgement on the quality and the artistic importance of the artists he selected. In 1914, at the abrupt end of his

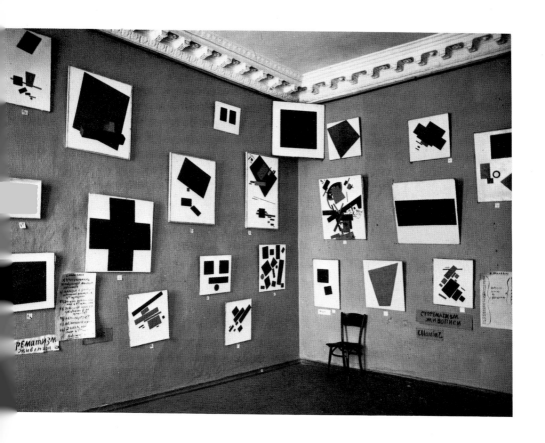

Malevich
First suprematist exhibition
Petrograd 1915

experience as a collector Shchukin owned among other things: forty works of Matisse, thirteen of Monet, and fifty-one of Picasso. Answering his invitation Matisse went to Moscow in 1911 to personally supervise the display of his works (including the famous pair "Dance" and "Music") in Shchukin's palace. As for Picasso's work, we can assert that since 1908 Shchukin had replaced the Stein family; up to 1914, he was the one to buy the best available works.

From 1910 onwards, the Russian artistic life experiences a real avalanche of new artistic groups and associations of different orientations. They constantly organized exhibitions and developed an intense theoretical activity by generating discussion groups and by publishing magazines and anthologies. Following the assimilation of French fauvism and German expressionism, in which Russian components (Kandinsky, Jawlenski, Werefkina) had played an essential role within the Munich group "Der blaue Reiter," the two movements that led the development of plastic arts in Russia are French cubism and Italian futurism. While in France the "cubist school" is an invention of anti-modernist critique, the term being applied at random to artists whose works rarely share the same basic principles, in Russia the analytic principles of cubist construction were seriously discussed: a genuine cubist school came into existence in 1912. Contrary to the critical approximations of Apollinaire, whose *Les peintres cubistes* of 1913 remains above all an "aesthetic meditation," as the book's sub-title specifies it, a real "cubist" theory is elaborated from 1912 onwards only in Russia. The analysis of cubism serves as a point of departure to the theoretical considerations of Burliuk, Aksenov and Markov, the latter being by far one of the most remarkable visual arts theoreticians of his time. The formal intuitions of Parisian painters whose works were regularly presented at Moscow exhibitions, received only in Russia a true theoretical formulation. What appeared intuitively—"metaphysically," Apollinaire would say—in the Parisian paintings received at Moscow a theoretical extrapolation and a remarkably "reasoned" plastic follow-up. In Russia, cubism acquired an "abstract" tonality which Parisian artists came close to, without however being able to assume it to its end.[3]

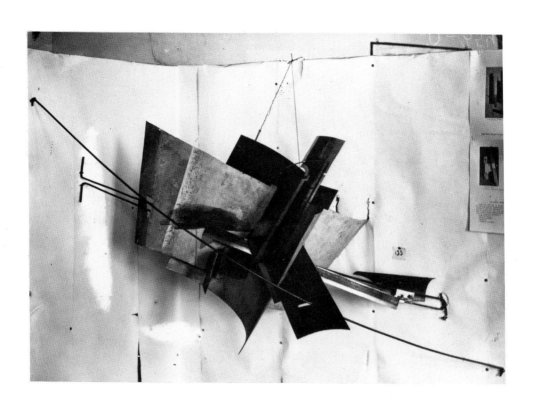

Tatlin
Angular counter-relief
1915

In the same way Italian futurism, scorned in Paris and Munich, received an enthusiastic welcome in Russia. Its themes, corresponding perfectly to certain modernist postulates of the Russian avant-garde, were expanded and reached a plastic fulfilment that one would search for in vain in the Italian production of the period. Furthermore, the movement called "futurism" in Russia was by far richer in its multiform flowering than the socio-patriotic logomachy implied by the Marinettian group. The Russian milieu was able to combine the innovating orientations of cubism and futurism, a synthesis which proved impossible in Paris. The Russian synthesis was above all of a conceptual nature. It was the work of several of its groups of artists whose meetings occurred at the Petersburg association "Union of Youth." This association, with cubist and expressionist ramifications (contacts with Kandinsky) absorbed for a brief period the Moscow futurists as well as the "Hylea" group of Burliuk. Within the framework of its public discussions, publications and representations, a common platform of revolutionary concepts was elaborated in 1913 which would lead several of its members to non-objective art.

During and after the winter of 1910-1911, the creation of a Moscow painter stood out clearly for the quality of his pictorial production and for the relevance of the problems he deals with: the work of Kasimir Malevich (1878-1935) constituted the driving force of a striking evolution which in ten years was to change the orientation and the foundations of western plastic art. With the emergence of suprematism, nothing would be the same again. Among the first-rank creators of their generation, Malevich and Rozanova were the only ones not to have taken the quasi-ritual trip to Paris and it is certainly not by chance that their creation was by far the most original. For it is not the direct contact with western artistic production—besides accessibility in Moscow exhibition halls—that was responsible for the astonishing evolution of Russian painting towards abstraction, but primarily its conceptual revaluation. The latter was perhaps easier to achieve in the solitude of Russian studios; it was stimulated better at a distance by an unbridled imagination. It served as a

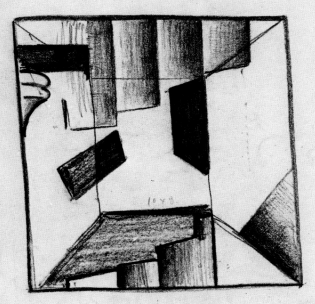

до поль брая лан

1ᵃ Сцена

билоа с черной

1° Деймо

Nₗ6₁u₅.

Malevich
Project for "Victory over the Sun"
1913

substitute for the direct experience of the Parisian scene by adding to it qualities of which this Parisian scene was far from assuming all the revolutionary implications. Another important factor must be pointed out in the conceptual evolution of pure (non-objective) painting in Russia: the close collaboration of painters, poets and literary critics[4]; the birth of modern linguistics being intimately associated with futurist poetry as well as the rise of non-objective painting. From 1910 onwards, a new relationship was being established between the image and the word, the symbol and the meaning. This direct and hardly dissociable interaction gives rise in 1913 to the "trans-rational" movement. The peak of that evolution is reached by the staging of a "futurist opera" with the significant title of *Victory over the Sun*. The play is the collective work of the poet Kruchenykh, the musician Matiushin and the painter Malevich, the latter participating at every level and as producer...of the images. The opera was staged in December 1913 at Saint Petersburg as part of the activities of the "Union of Youth." During a "trans-rational" narration, which breaks the ties with our world declared out of date, appeared for the first time "non-objective" elements—those pure pictorial planes. Having defeated "the reign of the sun" (that of the old "terrestrial" logic) the emergence of these pictorial planes established a new order situated beyond the limits of our understanding. Its logic refers no more to our "world of flesh," it was superior to it, that is why it needs no more the reference of the old aesthetic order, that of the hierarchy of "parts," of relations between "forms and colours." Their logic was definitely surpassed by the emergence of these non-objective planes which erased all possible reference to such an order of the causality of things. Malevich would need another year and a half of reflection before he could liberate his first intuitive forms from the trans-rational discourse and give them the coherence of a new plastic art system. That rupture occured during the summer of 1915 when, in the solitude of his Moscow studio, he painted a simple "black quadrilateral" on a white ground. That image turning point and "zero degree" of the new painting was not a painting like any other. That "first step of pure creation in painting" (Malevich) constituted the conceptual barrier between old painting and non-objective creation; it symbolized both a point of no-return

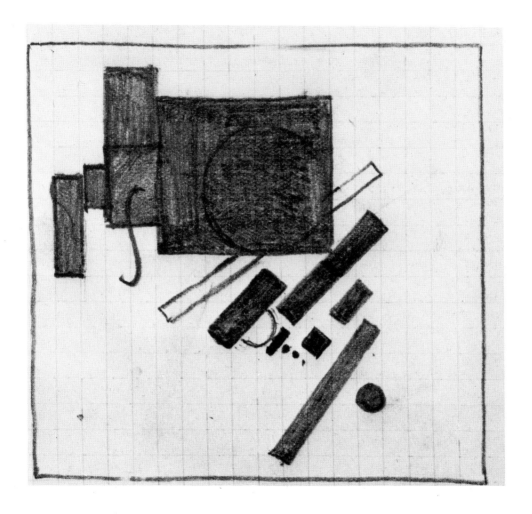

Malevich
Transrational composition
1915

and the beginnings of an evolution from the state of the "liberated nothing." The conservative critics who have interpreted that work as a negation of all painting (that of the past) were not entirely mistaken because it does represent the end of a certain kind of painting. At the same time it announces a new conception of painting, that of non-objective art. In his 1915 manifesto, quoted above, Malevich explained the "Black Square" as an "affirmation of the pure pictorial plane" and called it a "majestic newborn," a "royal infant." For him, "a coloured plane," this minimal and most simple form of manifestation of pure colour, "liberated from the oppression of objects," was a "living and real form (...) every (suprematist) form was a world in itself." This system of non-objective forms was made of "pure" planes, freed from all servitude towards any extra-pictorial reality or any imitative pretext (portrait, landscape, narrative scene). He named this new state of painting "suprematism," a term that doesn't exist in the Russian language and that the painter coined, being inspired by his mother tongue Polish.[5] It signified the *supremacy* of this new painting in relation to all that preceded it, the victory of "freed colours" and of pure emotion liberated from the servitude to the "world of objects."

"From illusionist representativeness to realist constructivity, Russian painting has taken several completely original steps, and often without any western influence. During this process it has progressively liberated itself from all exterior elements non-inherent within the plane, conceived as a point of departure of the form and the pictorial object."
Tarabukin, *From easel to machine*, 1923

Malevich's conceptual adventure was rich in new explorations and in no way developed in an ivory tower. His creation profited from a stimulating

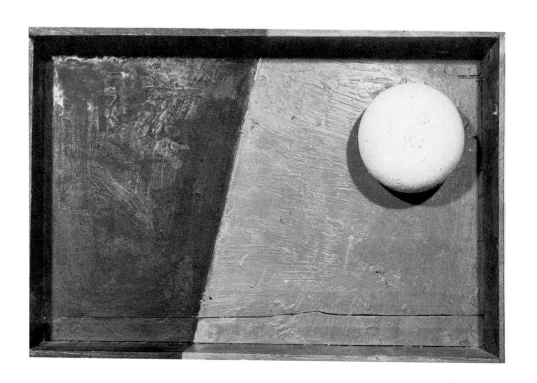

Puni
Transrational assemblage
1915

confrontation with other experiences of "after-cubism" foremost among which were the sculptures of Vladimir Tatlin (1885-1953). In 1913, after a Berlin journey, followed by an extended stay in Paris, this highly talented painter took up the practice of non-illustrative sculpture. His own autobiographical notes tell us, he discovered in Paris the reliefs of Archipenko and those of Picasso, whose studio he visited during the winter of 1913-1914. His first-hand knowledge of Boccioni's futurist sculpture remains hypothetical. It is, nevertheless, an established fact that the contents of the Parisian exhibition of Boccioni held during the summer of 1913, as well as the artist's revolutionary ideas in the area of sculpture, were immediately known in Russia. And it is perhaps to the phantasmagorical power of the latter that must be attributed the rise of non-objective sculpture in Russia. On 10 May 1914, Tatlin opened for five days his Moscow studio that he was sharing at that time with other cubo-futurist artists (Popova, Udaltcova, Vesnin). On the poster announcing the exhibition the works presented were described as "synthetico-static compositions," a title that indicates the futurist origin of the idea. The formal repertoire—geometric planes and sections of volumes—stems directly from the advanced cubism of Braque and Picasso, whereas the choice of materials utilised (metal, glass, plaster) shows once again Parisian and Milanese sources (the "poly-material" concept of Boccioni). Nevertheless, these compositions are not a servile imitation of western sources, they constitute a real step forward in relation to Archipenko and Boccioni. Unlike them, Tatlin represents neither characters nor "synthetic" futurist scenes. With the exception of his very first attempts, the reliefs of Tatlin were realised with purely geometric forms that bear no reference to real objects nor even to fragments of objects, as is the case with Picasso. Tatlin's innovation, like Malevich's, was conceptual: he drew the conclusions from abstract structure that the three-dimensional constructions of Picasso suggest. The first series of reliefs that Tatlin qualified as "pictorial" in the exhibition catalogue of the period was realised from a vertical plane (similar to that of the canvas, stretched on a frame and hung on the wall). The three-dimensional elements (rectangular or triangular planes, cones or conic sections) are set in opposition to this initial plane and move as if they were in

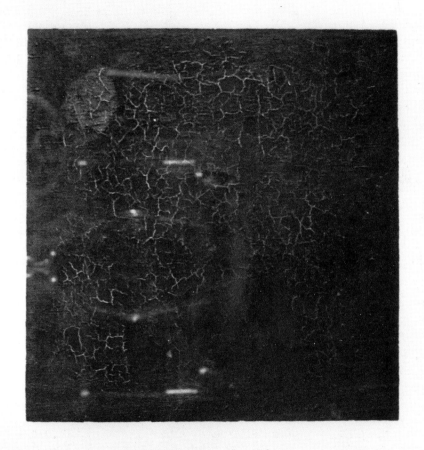

Malevich
Black quadrilateral
1915

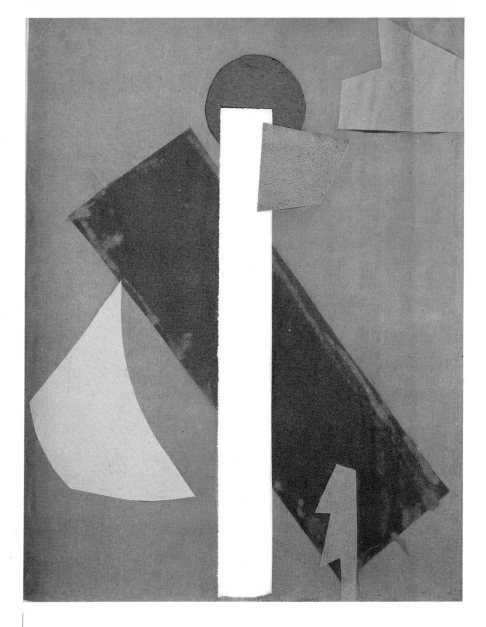

Rozanova
Collage for "The universal war"
1916

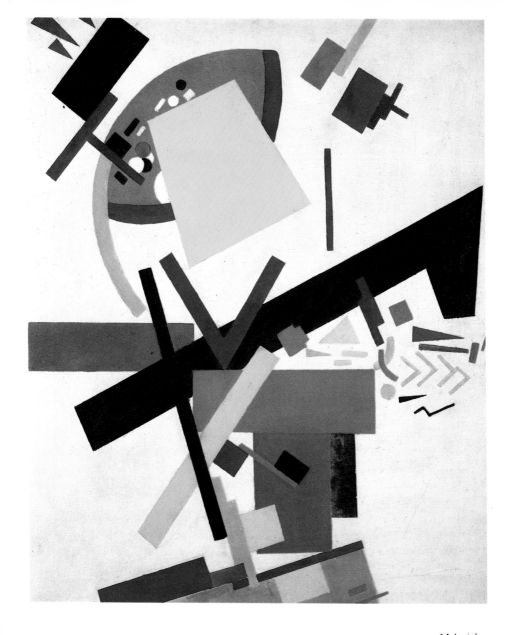

Malevich
Suprematism
1915

real space, from which probably originates the title of "counter-relief." First at all, the artist had to go beyond the experience of the cubist analysis (fragmentation) by projecting it into physical reality of the third dimension. This surpassing of the "relief" is accompanied by its mutation to the category of non-mimetic (purely geometrical) form. The founding principle of such assemblages will be brilliantly formulated some years later by the constructivist critic, Nikolai Tarabukin. In his text, *For a theory of painting* (begun in 1916 and published in 1923), he said: "The form of a work of art is elaborated from two fundamental moments: *the material* (colours, sounds, words) and *the construction* by which the material is organised into a complete whole, acquiring its artistic logic and its real meaning." In his reliefs of the years 1914-1916, Tatlin tried to bring out all the potential forces of the different materials used. This involved a series of material mini-explosions that the artist attempted to master by giving them (non-objective) form and an existential structure. Did not modern life constantly offer the example of similar poly-material confrontations that the modern engineer had to cope with? Let's imagine the technical (and emotional) problem posed by the speed of a train storming through a landscape. While Marinetti glorified the *impression* given by this speed and the *transfigurated image* of the landscape, glanced over by the spectator, thrown like a bomb into a world whose usual parameters suddenly vanished, Tatlin considered both the concrete results of the impact of matter, and the conceptual conclusions to follow. The modern engineer had to think of the metallic rails which could not be laid on the ground without the intermediary of wooden sleepers, themselves necessitating a bed of stones. The fanatical attachment of Tatlin to the study of the potential properties of materials led him during the years of 1918-1922 to the elaboration of a real metaphysics of texture. This subject, which was to preoccupy him to the end of his life, reached its most extraordinary culmination in the project of an "air bicycle" (the "Letatlin," 1928-1932), an individual flying machine whose driving force is derived from the movements of man. Ultimate proof of the Icarian utopia of Tatlinian constructivism, work on this project allowed the artist to obtain astonishing experimental curves, forms of a "trans-

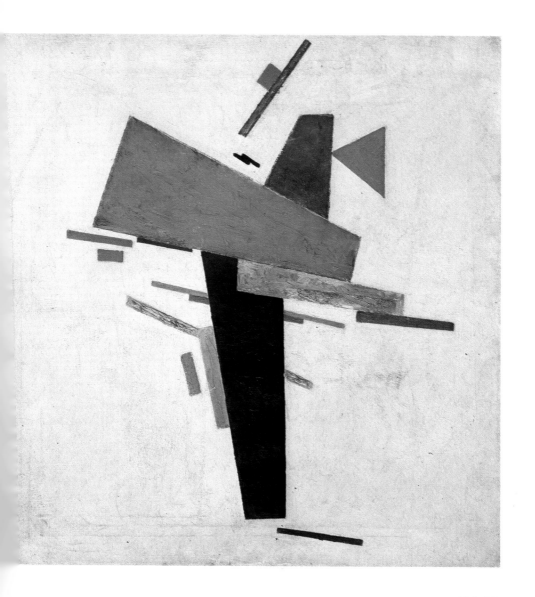

Malevich
Suprematist construction
1915

rational" kind which the science of aviation would make use of many years later.

To reduce the reliefs of Tatlin to a mere repertoire of geometric forms, a simple tridimensional superseding of cubism, does not exhaust the meaning of his creative endeavors during the years of 1914-1916. In 1915 appeared a series of "angular reliefs" which followed the "pictorial" reliefs. Certain critics with a narrow, positivist mind have looked upon it as the passage "from the surface to the space,"[6] an observation justified in itself, but which does not exhaust all the meaning of this mutation. The "angular reliefs" of 1915 showed actively a fundamental idea of the new, non-objective visual arts. This second series of reliefs detached itself completely from the mural support in order to throw itself freely into space. Suspended by iron wires and placed in a diagonal way, these constructions attempted to escape the usual conventions of our spatial references: they avoided any reference to our fundamental categories—the horizontal and the vertical. The dynamism thus obtained had the further result to situate the construction suspended in this manner in a position of "an escape" from the categories normally applicable to this type of material structure. The diagonal extirpated the non-objective construction from its immediate/usual surroundings. The angular reliefs of Tatlin were presented to the public for the first time in December 1915, at the "Last futurist exposition:0.10," at which were displayed the suprematist canvasses of Malevich. The originality of their spatial projection—without either pedestal or wall behind them—gave them the status of a new freedom in relation to the surrounding world. They created their own auto-generated space. The space which circulated between the different, intersecting geometric forms, these hollows (the famous "holes"), which in 1913 and 1914 had so shocked the Parisian critics in the works of Archipenko, became an integral part of the new construction. The space opposed itself no more to the "carved" mass; it ceased to encircle an inert and full form; the "void" (pure space) became interchangeable with the mass. The transparency of the glass and the reflection of the mirror in Archipenko's works destroyed in their turn the illusion of a closed

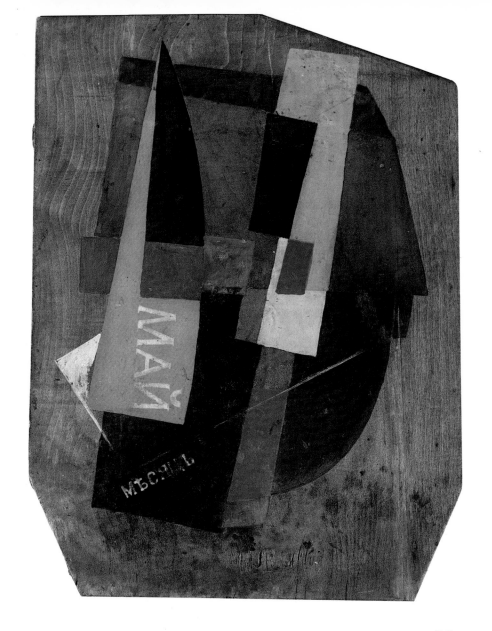

Tatlin
Non-objective composition
1916

volume. By opening itself out in all directions, the volume became a concept of (dynamic) space and not of static matter. Non-objective plastic art abandoned the slavery to objects. It became a structure: the concept was ready to occupy definitively the place of the (real) object.

Unlike Malevich or Kandinsky, Tatlin never produced a theory; nor did he write didactic texts or manifestoes. Only a remarkable series of analytic drawings of the year 1914[7] attests to his work on the conceptual dematerialisation of forms which led him from the cubist analysis, up to the non-objective constructions of 1915.

The third Russian creator to arrive at non-objective art at the same time as Tatlin and Malevich was Olga Rozanova (1886-1918). In the early stages (1912-1913), her conception of painting was close to the expressionist postulates of Vassily Kandinsky to whom her theoretical texts of the year 1913 show an undeniable link. Nevertheless it was once again the rigour of the cubist analysis and its association with the trans-rational conception of the image which led her at the end of 1915 to the borders of abstraction. During the memorable exposition "0.10," Rozanova exhibited several trans-rational works whose non-objective forms came from the same extrapolation of "trans-rational" forces as did the suprematism of Malevich. In January 1916, she completed the illustrations for a selection of "trans-rational" poems of Kruchenykh, entitled *The Universal War*. Some months earlier, she had produced her first abstract collage: the cover for *The War*, another book by the same poet. The series of illustrations for *The Universal War* is composed of twelve abstract collages of an exceptional plastic quality. Through the liberty of the imagination and the finesse of the forms, associated with a refined choice of materials, these collages constitute one of the peaks of the first phase of non-objective Russian art. Cut out from papers of different textures, these collages reconcile the textural postulates of Tatlin with those of the plane that Malevich's suprematism required. The visual poetry which emerges from these works with a quasi-immaterial fragility bestows on them an

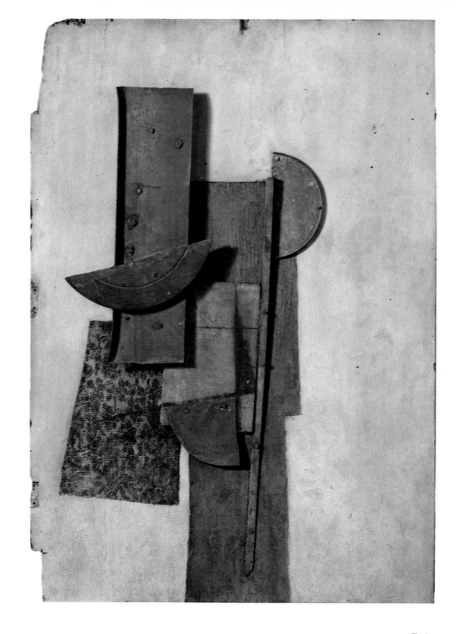

Tatlin
Synthetico-static composition
1914/1915

exceptional place in the history of abstract art. Forty years later, Matisse, gathering the fruits of a superb pictorial maturity, arrived at similar solutions, but they rarely convey the poetic intensity of Rozanova's creation.

The evolution of Rozanova's non-objective art was, later on, to follow an original path. While participating in the "Supremus" circle of Malevich, she developed an autonomous way of thinking, proved by her rare works that survived the revolutionary tumult. Contrary to the immateriality of principle which the suprematist planes by Malevich are supposed to attest to, the composition of Rozanova's non-objective masses was articulated by the principles of a logic of (visual) weight of colour. The distribution of forms seems to follow the "aspirating" forces of an extremely dynamic space. One is equally surprised by the formal amplitude of this artist whose first non-objective works approach the rigidity of Tatlin's reliefs, while her last non-objective canvasses of the year 1918 convey the metaphysical anguish of a Barnett Newman. The premature death of this highly talented painter prevented her from realising a corpus of works which would have unboubtedly influenced differently the history of art of this century. Is it with the presentiment of the fragility of her existence or with an enthusiasm for an immediate social integration of non-objective art that, since the beginning of 1918, Rozanova looked forward to introducing suprematism in textiles? Actively engaged in post-revolutionary artistic organizations, she was one of the first to inscribe her non-objective creation on daily realities (objects, interior decoration, etc.).

"It is impossible to create while using
forms already discovered, because
creation is change."
Shklovski, 1919

Malevichian suprematism provoked a profound upheaval in the ranks of the cubo-futurists. It accelerated the evolution of several "visual artists" who had already taken that direction, without however reaching the non-objective state. Among them were Popova (1889-1924), Udaltsova (1886-

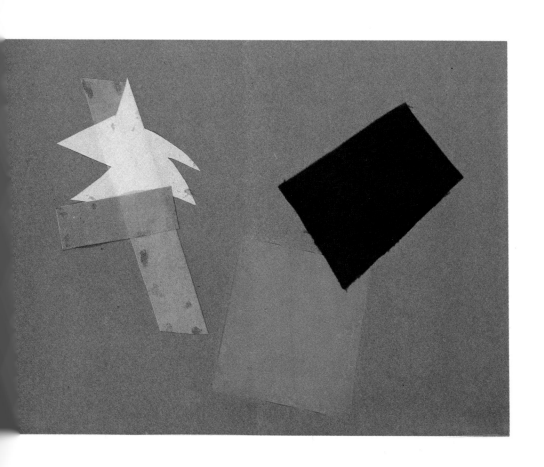

Rozanova
Collage for "The universal war"
1916

1961), Exter (1882-1949) and Kliun (1873-1942). The latter was, from 1912 onwards, a friend and protégé of Malevich. He was engaged with Malevich in the wake of cubo-futurism and in 1915, with him and Ivan Puni, signed a suprematist manifesto, a leaflet which was distributed during the "0.10" exhibition. If one could speak of a direct follower of Malevichian work in 1915, Kliun would be the only example, because he knew perfectly Malevich's work, having rented to him some rooms in his house. At the memorable "0.10" exhibition Kliun exhibited a series of non-objective sculptures and signed a manifesto of the "suprematist sculpture." This text, without great intrinsic importance, has nonetheless the merit of materialising the tridimensional orientations of suprematism. Kliun's sculpture, of which only an insignificant fraction exists today, evolved since 1914 in the plurimaterial orientation of the cubo-futurist line, a principle perpetuated in the non-objective works of the years 1915-1917. It testifies to a certain formal invention, what one can affirm in a more modest extent about his painting, which remained directly attached to the Malevichian example. Until 1918, Kliun was slavishly inspired by Malevich's production and produced without any innovation suprematist paintings of which some are of the best quality. Explaining sometimes in an ostentatious manner the relations of power with lines which connect with suprematist planes, he provided on certain occasions a kind of didactic extension of energising virtualities of non-objective planes. Intimately attached to the sensuality of the image, he could no longer follow, from 1918 onwards, Malevich's evolution and broke away openly. Thus, during the years 1920-1923, his pictorial production came closer to the luminism of Rodchenko. Lacking a mentor as of the mid-twenties, he fell back into the rut of Parisian purism, of which he is an exceptional reflection in Russia.

As for the second signer of the 1915 "suprematist" leaflet—Ivan Puni (1894-1956)—his enthusiasm for the non-objective art was of a much shorter duration. Having organised the two important "futurist" exhibitions of the year 1915 ("Tramway V" and "0.10"), he knew since the month of September 1915 Malevich's suprematist creation, as well as Tatlin's angular reliefs. Inspired directly by these two examples, he produced a certain

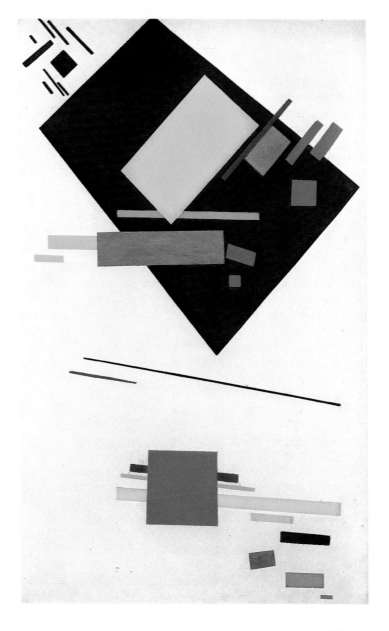

Malevich
Suprematism
1915/1916

number of reliefs which combined the properties of the Malevichian trend with the poly-materiality of Tatlin's works. His non-objective and "trans-rational" work was limited by the immediate proximity of the above mentioned exhibitions. It does not show any real evolution. Having emigrated to Berlin at the end of 1920, he quickly renounced non-objective art by returning to the "new objectivity"; his stylistic process between 1920 and 1922 constitutes one of the most remarkable didactic demonstrations of this "return to order," a sinister slogan to which other adherents would give a social dimension many years later. In his book, *Contemporary Painting*,[8] 1923, Puni never failed to denigrate the principles of non-objective art.

The pictorial work of Popova and that of Alexandra Exter occupy a completely different position in the history of non-objective art of the century. Their evolution shows some similarities, due to a large extent to the personal contacts of these two artists in 1916, as well as to their predilection for the futurist dynamic. On returning to Russia in 1916 after numerous extended stays in Paris, Alexandra Exter brought to the newly emerging non-objective art not only the futurist experience of the last "synthetic" period of Severini, Boccioni and Archipenko, but also an intimate knowledge of the colourist dynamic of her friends Sonia and Robert Delaunay. She knew very well the pictorial problems of the latter, as she stayed for a long while at the country home of the Delaunays at Louveciennes.

Impassioned by the theatre, Exter created in Moscow, in 1916 and 1917, some decorations and costumes for the director Tairov. The colourist's exuberance, the formal rigour and the dynamic ordering of her forms were going to disrupt the customary practices of the Russian theatre. In the play *Thamir the Cithарœdus*, she surprised the audience with her dynamic treatment of the actor's body (painted and already considered as an ensemble of basic forms in movement)—whereas, in 1917, the decorations for Oscar Wilde's *Salome* were most definitely suprematist, the light effects adding to the impression of a non-objective dematerialization of the geometric forms moving back and forth on the vertical. Departing from a

Tatlin
Malevich and Kliun
1916

logic of the materiality of colours, Exter developed in her paintings of 1916-1917 a system of dynamic relationships between overlapping forms, which became the source of the illusion of movement. The laws of this new painting, moved by the dynamic of colour—a determining factor on the level of the forms which stem from it—are at best reflected in a portfolio of "constructions" of the year 1916 with the eloquent title, "Explosion, Movement, Weight."

By exploiting this new metaphysics of colour, the non-objective Russian painters developed in the realm of art the counterpart of a conceptual revolution which for more than half a century had nourished innovations of technique and electrodynamics, producing in particular the concept of the electro-magnetic field.[9] Without applying themselves to illustrating a scientific concept, the non-objective painters arrived on nothing but the strength of the new logic of the "dynamic virtualities" of material at this new vision of the world, illustrated in the realm of science by the inventions of Maxwell, Minkowski and Einstein. It is not surprising that at a time when the discoveries of science entered everyday life (radio, electric light, internal combustion engine), the reality of their principles should be taken seriously by art whose foundations were in turn overwhelmed by this new state of relations between elements. And, it is certainly not by accident that in 1918, when non-objective painting reached the climax of its second phase, the central subject of its experiences was enriched by reflection about the energetic force of light. At that moment, non-objective painting no longer used light as a kind of catalyst of representation meant to reveal the qualities of an (other) subject inside the picture (still life, landscape, portrait, etc.); it was light as an object, a formo-creative material, which became the subject of pictorial representation. Also, the pictorial planes lost their value as precise molecules, they ceased to be the bricks of a construction, and colour broke away from the limits of a geometrically defined form in order to transform itself into waves of light. Like cosmic rays they cross the pictorial composition implying at the same time the notion of an infinite space which goes beyond the field of the picture. Thus the field becomes open. The first steps in this direction can be seen in

certain futurist compositions of Balla and Larionov, where these artists deliberately extend *the scope* of the picture over its frame (the frame constitutes thus the extension of the canvas and not its limit).

This tendency towards the dematerialisation of the pictorial plane marks the evolution of Malevich, as well as of Exter, Popova and Rozanova, among whom the notion of field began to predominate over that of formal, precise unity (the non-objective form). Still using metaphoric language —but how precise at the same time!—Malevich would say in his suprematist manifesto of 1919 that "at this moment the path of man goes through space. Suprematism, the semaphore of colour, places itself in its infinite abyss." And he would insist on the "philosophical character" of this "system of colour." If Malevich's ambition was to encourage painting to question itself on its ontological limits, on the philosophic and existential boundaries of its being, other painters with much more pragmatic minds engaged themselves in treating the formal problem of non-objective painting with a kind of illusionist virtuosity. This is the case of Alexander Rodchenko (1891-1956) who, during the year 1918 alone, produced various types of non-objective compositions whose stylistic differentiation results from the "lightning," the "illumination," the "effervescence" or the "evanescence" of the light.[10] While in the case of Rodchenko, this problem resembled somewhat the identification of a chemist, for the direct descendants of suprematism the relationships between pictorial planes—in which the dynamic encounter had to constitute at the start a kind of framework or a grammar of formal unities of pictorial discourse—was transformed in 1918 into a confrontation of energetic fields, into a kind of fire of cosmic rays in which the precise materiality of planes gave way to a qualitative mutation of matter. This gradual disintegration of the notion of the pictorial plane seems to inscribe itself in the metaphysics of the new cosmic adventure, which made its first appearance during 1913 in the futurist "opera" *Victory over the sun.* In the second half of this piece are presented the laws which govern the "new world," this new existence, achieved after the *Victory over the sun.* Describing a kind of "a world backwards" the poet Kruchenykh shows an another *state* of things where the rules of conduct are

different from those that determine our "terrestrial" existence. Every being has the possibility to go through different *states* of existence (the same for matter where the solid, liquid, gaseous, etc., states exist). This quasi-alchemic insistence on the possibilities of the dynamics of transformation of the *state of things* constituted the starting point for Malevich's reflection on the possibilities of suprematism's evolution. The idea of "states" of things was already part of Boccioni's futurist discourse, but he dwelt mainly on their psychological signification, which he endeavored to illustrate in a series of works famous today.[11] For the Russian futurist, however, it was the non-descriptive but the real states of the matter that counted, just as in modern technique it is the principle of the transformation of combustible matter from one state to another which constitutes the energising philosophies of the centuries to come. (Let us think of the internal combustion engine, of the electromagnetic field or of nuclear energy.)

"It is the lonely traveller who goes the
furthest."
Celine, *Journey to the end of the night,*
1932

As early as 1915, Malevich asserted in his text *From Cubism and Futurism to Suprematism* that "the dynamism of movement gave the idea of promoting the dynamism of pictorial plastic art (. . .). Painting will be the way to convey this or that state of forms of life (. . .) The state of objects has become more important than their essence and their significance." Having spent a brief period exploring the manipulation of non-objective forms (in suprematist planes) according to the laws of elementary dynamics ("speed, weight and direction of movement"), the creator of non-objective painting commited himself in 1917 to the study of different states of the suprematist plane. With his vanishing (or appearing) planes, he attacked the existential limits of painting. While until 1917 the suprematist pictures had abounded in a multitude of forms in movement, the formal repertoire of a single composition was reduced as of mid-1917 to two or three planes to achieve in 1918 the presentation of a unique plane, or a part of this plane (in

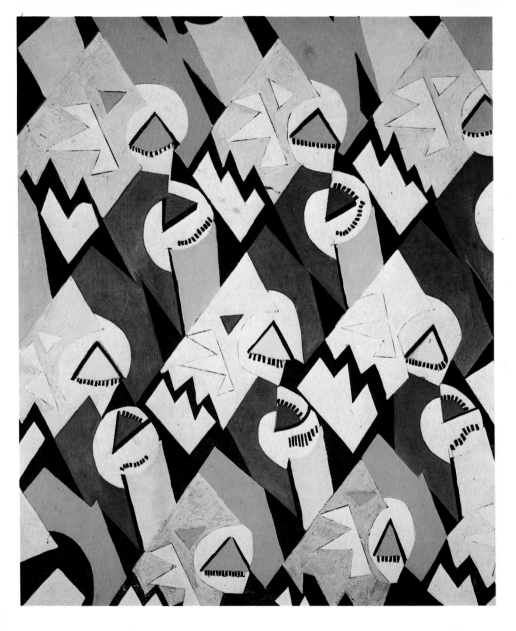

Rozanova
Decorative composition "Supremus"
1916/1917

the case of vanishing planes). The same purification affected the colourist problem. At this moment, the painter abandoned the richness of the expressionist palette which had nourished his pictures of the years 1915-1916. In 1918, he came to white-monochromatic compositions. On 15 June 1918, he wrote a *White Manifesto* in which he announced the pure conceptualisation of suprematism. Characterised as "pure action," it became a kind of concept and pure mental energy. In this brief text Malevich glorifies "the revolution of pure mind," that of "superman." He announces the superseding of materially experimental knowledge and asserts the authority of spatial concept—that of the (white) infinity. From that moment on, this spatial consciousness defines the new suprematist consciousness—i.e. that of the man who assumes the philosophical consequences of this new world vision. Malevich painted then a series of white pictures which included a "white square" (on white ground). Unlike the first (black) square, the white composition of 1918 was not static. The surface of the square is cut by a diagonal movement, an arrangement which accentuates the impression of dynamism: one has the feeling that the space draws the square towards the white infinity.

The consequences of the "white" evolution of suprematism were not slow in coming: Malevich himself assumes in a promethean way all the responsibility for his conclusions. The invention of the *Suprematist Concept* having led to "pure action," the plastic artist considered that creation no longer utilised the cognitive activity of the pictorial practice; declaring "to abandon the ruffled brush for the sharpness of the quill," he devoted himself to the production of theoretical texts, thinking that at this stage "there cannot be a question of painting in suprematism. Painting has been obsolete for a long time and the painter himself is a prejudice from the past" (1920).

These declarations had a bomb-like effect. The consternation in the ranks of his colleagues reached its pitch. Most of them dissociated themselves openly from Malevich during the exhibition "Non-objective creation and suprematism" (Moscow, 1919). Rodchenko, faithful to a

formalist instinct in evidence as of his first non-objective attempts of 1915, presented a sort of materialist answer to the "white on white" of Malevich: "black on black" pictures (circles and ellipses with a heavily emphasized texture). Followed by a certain number of his colleagues, he threw himself in the middle of 1919 into the "lineist" adventure, which constitutes the negation of the visceral pictoriality of the year 1918. "Lineism," practised in Russia between 1919 and 1922, suppressed the material sensuality of the pictorial plane in order to replace it with a conceptual reduction of the single straight line. This line was as infinite as had been the last vanishing planes of Malevich, Popova or Exter, but, contrary to the metaphysical allusions of the suprematists, Rodchenko's reductivism had the advantage of offering the tools for a simple and precise manipulation. It suggested moreover the possibility of a direct escape toward the pragmatic reality of utilitarian objects. From the summer of 1919 onwards, the cleavage between Malevich and his colleagues of "constructivist" orientation became clear: the creator of non-objective painting remained on the side of the "pure" (conceptual) evolution of a form entirely made up and destined to satisfy philosophic interrogations and ideals, while his opponents, who were soon going to endorse the "productivist" label, advocated the abandonment of the pictorial practice in order to concentrate solely on the reality of the concrete material— to create "real" forms meant for immediate use in daily life.

For a while, the critics and artists found subterfuge behind the façade of a "laboratory" function of non-objective art. The "pure" practice of the non-objective artists was acceptable from the perspective of an "experimental" vision, "in view of something. . . " The existence of a non-objective art in its "constructivist" version was accepted as a stage preliminary to other knowledge. The theory of art as a means to knowledge, with which certain critics tried to neutralize suprematist innovations as early as 1917, resurfaced in 1919 in the writings of Nikolai Punin as well as in the Muscovites' discussions of the year 1920. Its appearance marked a first step towards the forsaking of the autonomous existence of non-objective art. Art had to openly serve another cause: its ontological maturity lived only during the brief years of the suprematist infatuation of Malevich's

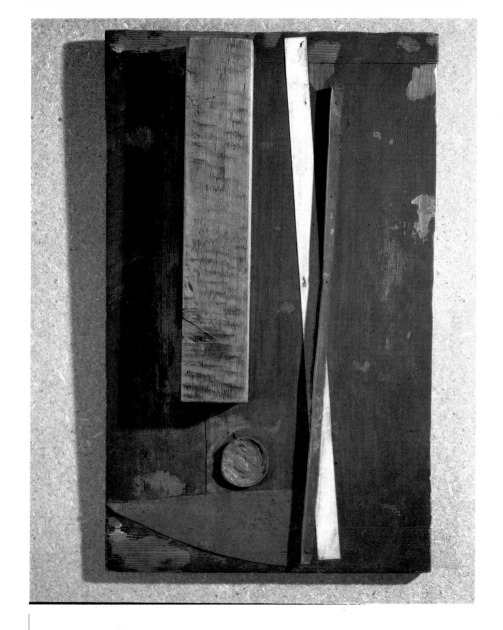

Kliun
Non-objective construction
1916/1917

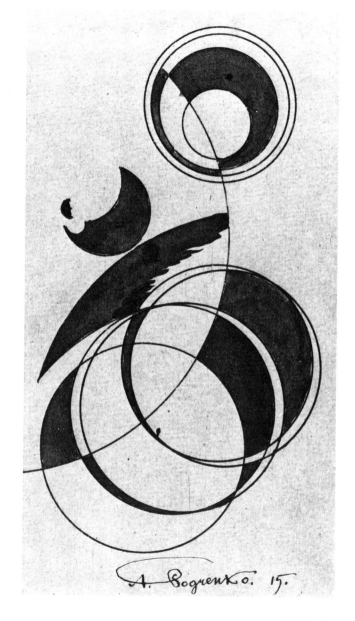

Rodchenko
Linear composition with compass
1915

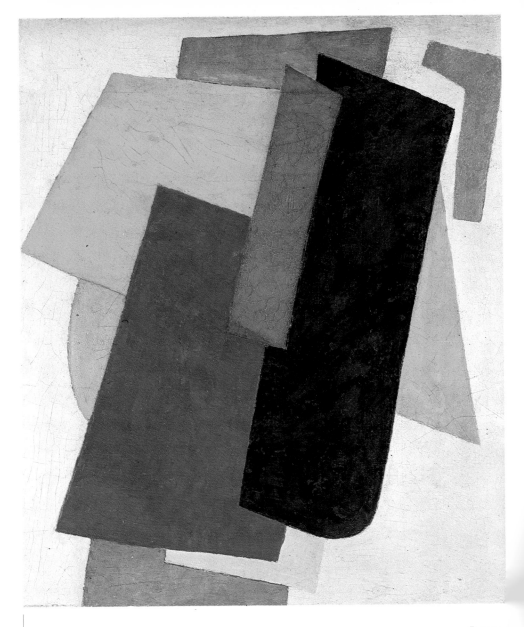

Popova
Non-objective composition
1916

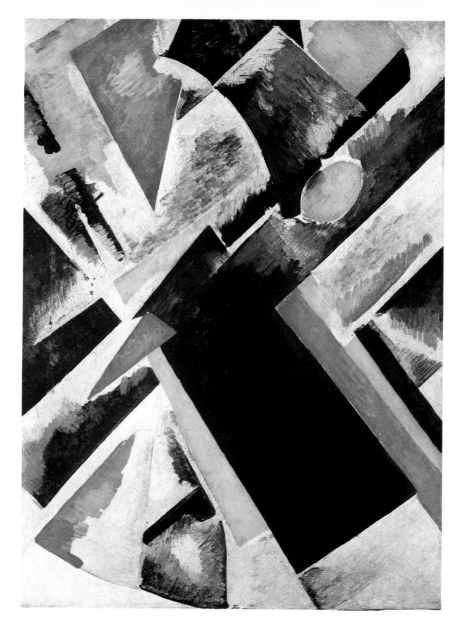

Exter
Non-objective composition
1916

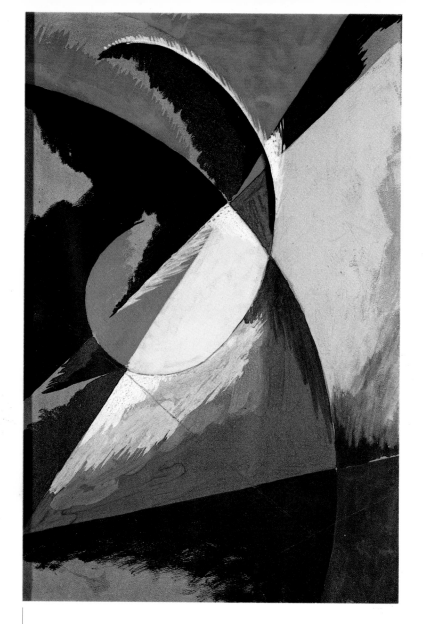

Popova
Non-objective composition
1917/1918

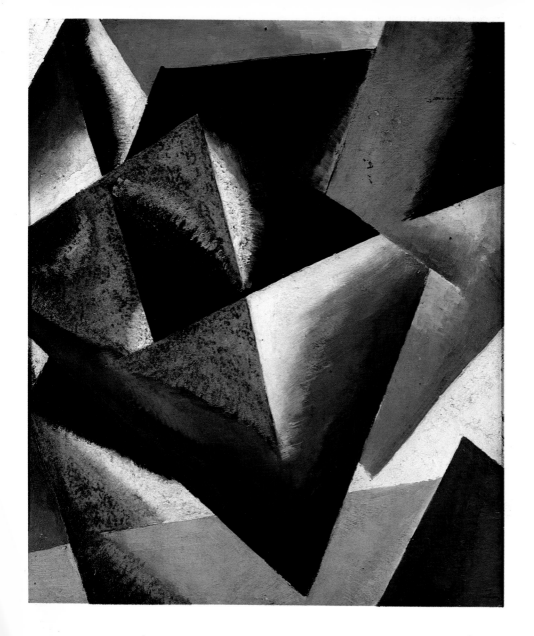

Popova
Architectonic construction
1918

colleagues. The theatre and applied arts served as a means of escape for plastic activities and were immediately able to give them the legitimacy of a "non-parasitical" activity. The (philosophical) repudiation of pictorial practice to which Malevich superposes in 1919 that of purely conceptual creation (ideal creation of models) found a materialist counterpoint in 1921. During the summer of that year, Rodchenko painted three monochromes: blue, yellow and red. Following "the assertion of spatial construction" in 1918 and that of the line (in 1920), he affirmed—in September 1921—"for the first time in art the three fundamental colours."[12] In a commentary of rare foresight Tarabukin, the critic, qualified these three works as "the last pictures" and spoke of the "suicide of the painter." A few weeks later, the ideologue of productivism—the (literary!) critic Osip Brik—had twenty-five painters, members of the Moscow Institute of Artistic Culture, vote on a "resolution," which he rightly qualified as "historic." In this text, they declared they "would give up in the future pictorial practice, the creation of pure forms" to devote themselves to the sole "production" (of material goods or to their immediate project). With the creation of "pure forms" becoming socially useless, the "constructivists" renounced the utopian function of art. The "productivist" ideology would from now on replace the search for ideal models. The painter who had had such difficulty liberating himself from the hold of objects and subjects returned to being this time the slave to another reality. At first, it had the reassuring aspect of an artisanal apron; soon it would be pure and simple ideology dictating to him the laws of pictorial practice. Back again, in full force by a conceptual detour by all accounts naively perverse, this reality would assure the monopoly of forms and subjects. It became clear that the "crossing of the desert" which Malevich had invited his colleagues to undertake in 1916 was not whithin the grasp of just any holder of the brush. As the Polish poet Galczynski would say, "the wind was too strong for (their) fleece. . . " However, the metaphysical wind to which Malevich had bravely opened the door of his studio was to sow the seeds for future generations: that of Kobro and Strzeminski in Poland, Moholy, Vordemberge and Schwitters in Germany, Newman and Rothko in the United States and Yves Klein in France.

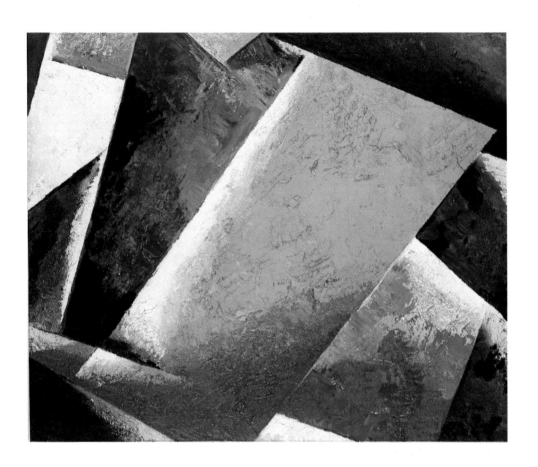

Popova
Architectonic construction
1918

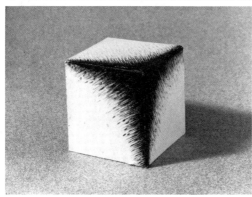

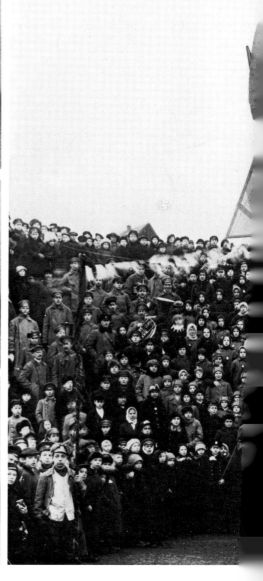

Miturich
Plastic alphabet
1918

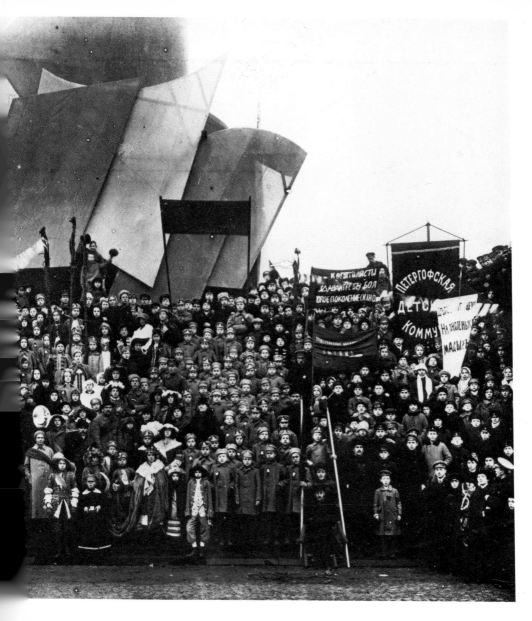

Altman
Monument for the anniversary of the
October Revolution
1918

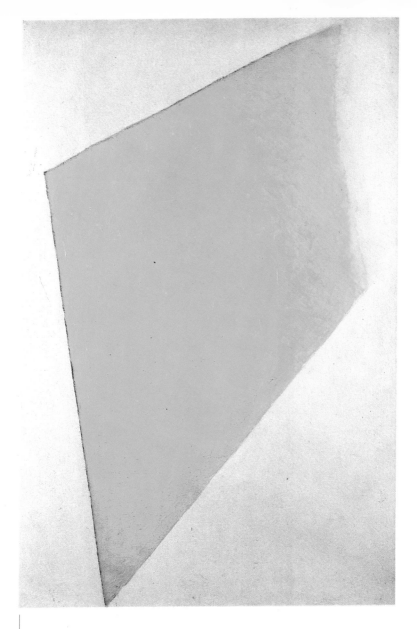

Malevich
Yellow suprematism
1917

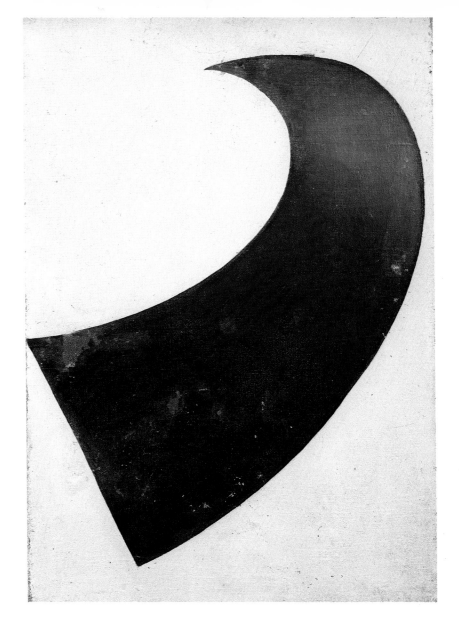

Malevich
Suprematism (disappearing plane)
1916/1917

PART TWO

Art into life: the dramatic evolution

The sharp evolution of Russian non-objective art was accomplished during the years of the First World War and followed by the revolutionary tumult and the dreadful ravages of the civil war. Whereas a great lull existed in the West during the years 1914-1918, the Russian milieu had a vitality equaling the quality of its production. Just as Malevich's "Black Square" put an end to futurist practice, so the "0.10" exhibition constituted the end of a series of public manifestations at which the carefree freshness of the Moscow groups opposed itself to the rather affected refinement of the Petersburg circles. December 1915 marks the end of the Moscow-Petersburg rivalry; before becoming the capital of Russia, Moscow emerged as the centre of innovation in art. Between 1916 and 1921, it was there that all the significant confrontations took place.

At the beginning of 1916, Malevich's suprematism had not extended beyond an intimate circle, and Tatlin tried to counteract its rise. He organized in Moscow a "futurist" exhibition called "Magazin." The participants, among whom figured some of the finest creators in the avant-garde—Popova, Exter, Kliun—were authorized to show only "futurist", works. Malevich participated in this as well with pre-suprematist (cubo-futurist and trans-rational) works. Apart from the angular reliefs which stylistically assured Tatlin's domination, the most advanced works on the level of forms were provided by an unknown youth from Kazan. It was Alexander Rodchenko exhibiting some of his first abstract drawings, realised "with the help of the compass and the ruler." As he would explain much later in his text on "the line" (1921), since the end of 1915 he was motivated to eliminate from the pictorial practice the contingency of the "small sensation." This "imprecision of the hand" was overcome by the use of mechanical means, destined to guarantee an indisputable objectivity; thus the concept of a mechanical abstraction was asserted for the first time as a stylistic definition.

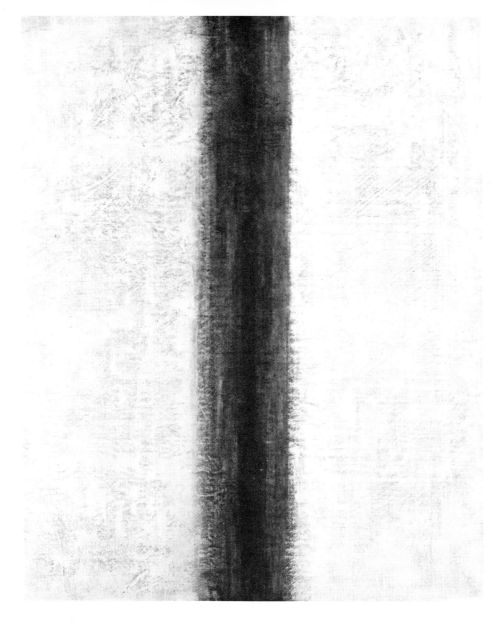

Rozanova
Non-objective composition
1918

Only a short distance separates this concept from a declaration of machine's superiority to man. It would be covered by Rodchenko and his "productivist" colleagues between 1919 and 1922. While carrying a hint of this formalism that Rodchenko had acquired during his experience of "art nouveau," his drawings constitute an original chapter of non-objective art. The technicist precision which replaced futurist trans-rationality superseded in one leap both Picabia's romanticism and the mannerist rigidity of the British vorticists: it anticipated the "aesthetics of the engineer" which blossomed in Russia after 1918.

In Moscow, a suprematist circle was quickly formed around Malevich, who from 1915 onwards dominated non-objective painting. The "Supremus" group, whose structures resembled that of the famous linguistic circles, more accurately, that of Freud's Vienna seminar, aims at practice and the theoretical development of non-objective painting. Popova, Rozanova, Udaltsova and Kliun constituted the backbone of these suprematist seminars. Udaltsova's studio served as a meeting place. They discussed there not only the problems of painting but also those of its extrapolation towards other domains of intellectual life. The project of a journal was put forward by Malevich in the fall of 1916. The preparation of the first issue was already well advanced in the beginning of 1917 when the February revolution broke out and impeded the publication. The aim of this project was to lead suprematism beyond the limits of the plastic arts. As Malevich had announced in 1915, suprematism was not a pictorial style but a philosophy of the world and of existence. He therefore envisioned for the *Supremus* journal articles not only on the plastic arts but also on music "suprematist!", poetry, philosophy, etc. Collaboration with Roslavets,[13] the composer, and Kruchenykh, the poet, was sollicited, while Malevich himself prepared texts on new music and poetry.[14] Malevich's ideas at that time show a striking similarity to those of Kandinsky, the only difference being that while Kandinsky saw the future of art in the "monumental synthesis" of different types of expression (plastic arts, music, poetry), Malevich, considered plastic arts as a kind of guide to and initiator of a massive extrapolation. The future "academy" of the new art was not

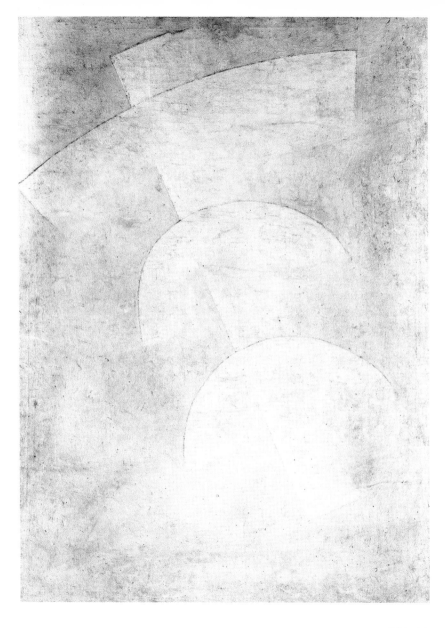

Malevich
White suprematism
1917/1918

far; the two would apply themselves during the twenties—separately and without success— to its edification.

The first part of 1916 being heavily dominated by military activity, artistic life seemed to cease for a moment. Several artists, including Malevich, were mobilised. Exhibitions resumed in the fall with the show of the association "Knave of Diamonds." Oriented towards the Cézannian and Expressionist stream, this association had interrupted its activities in 1914. The 1916 renewal took place under the impetus of the suprematist group. After a brief opposition by Tatlin, who was unable to stem the suprematist tide, Malevich was elected president of this association, a post he was to occupy for only a few months. In November 1916, the "Knave of Diamonds" exhibition was literally invaded by non-objective painting: Malevich alone showed sixty suprematist canvasses. His friends of the "Supremus" circle participated under their individual names: Rozanova presented twenty-four works, eight of them being non-objective compositions; Kliun contributed nine suprematist paintings with very elaborated titles as well as with seven sculptures. Udaltsova exhibited three (non-objective) "pictorial constructions" and Popova six "pictorial architectonics." Popova's works asserted a dynamic particularity whose consequences would be decisive for the evolution of future constructivist painting. Contrary to the autonomist logic of Malevichian suprematism, where any direct relation of the non-objective forms among themselves was excluded,[15] Popova conceived her paintings in the fashion of Tatlin's angular reliefs. In her compositions, the pictorial planes, far from indulging in the "free flight of forms" put forward by Malevich, plunged into a real struggle of forces. In these clashes of planes is elaborated a new logic of non-objective painting: the logic of energetic outcomes. This constructive dialogue is also implied in Alexandra Exter's paintings. She occupied during the years 1916 and 1917 an exceptional place in the evolution of Russian non-objective art, of which she represents at that time one of its most original poles. Settled in Kiev, Exter made frequent trips to Moscow, but it was in Kiev that she developed an original constructivist method. Her compositional activity like Popova's was based on the cubo-

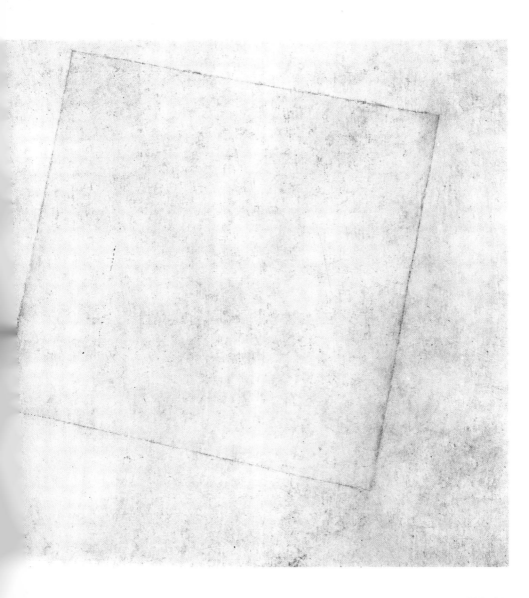

Malevich
White square
1918

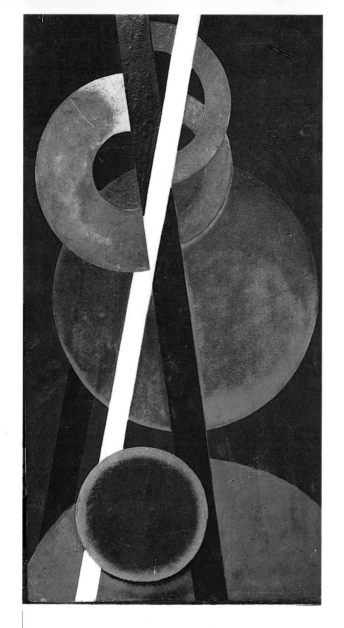

Rodchenko
Non-objective composition
1920

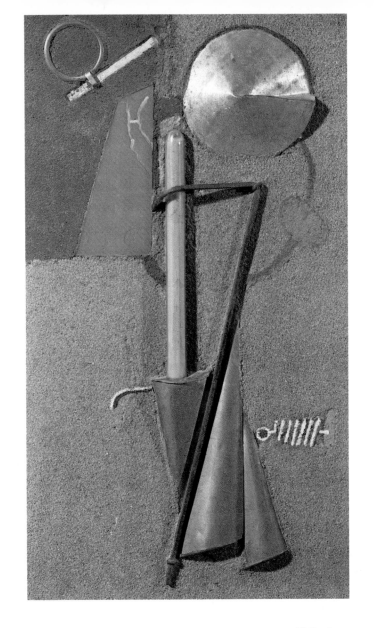

V. Stenberg
Non-objective composition
1919

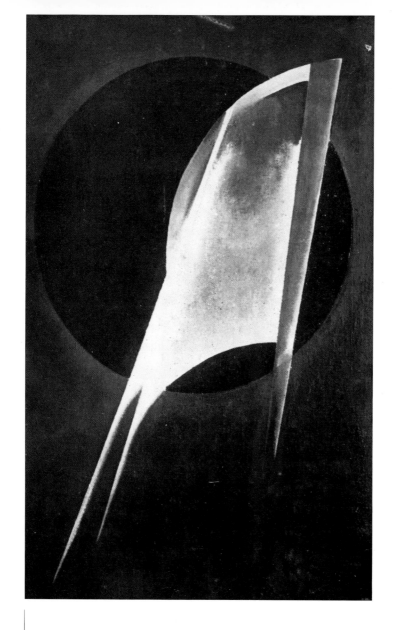

Rodchenko
Non-objective composition
1918/1919

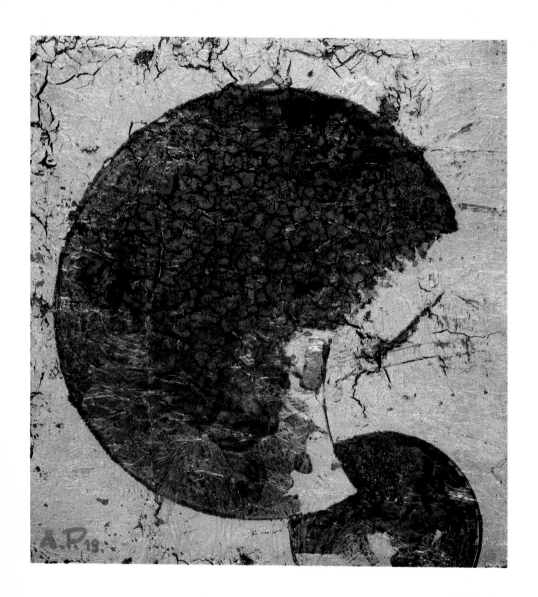

Rodchenko
Non-objective composition
1919

futurist practice acquired during long Parisian sojourns; (before 1914, she became friends with Léger, Delaunay, Picasso and Braque, just as she frequented the pro-futurist circles gravitating around the Apollinaire journal *Les Soirées de Paris*). Her conception of non-objective construction relies on the a-priori existence of a central energetic knot, which, in a kind of cosmic explosion, must create a multitude of forms: rectangular and circular. Having overcome by the end of the year 1916 some weakness of a decorative inclination, Exter produced in 1917 some of the most original works of the times. In 1917, she opened in Kiev, and later on in Odessa (1918), the first school of abstract art for children where she elaborated revolutionary methods of teaching. Preceding for a little while the Malevichian pedagogy at Vitebsk, in a few months she made her young students get over the stylistic grammar of modern art, thus leading them to non-objective forms.

Among the rare artistic events which marked the autumn of 1917 in Moscow, let us draw attention to the première of the play *Salome* by Oscar Wilde, in the audacious interpretation by Tairov. The suprematist decoration and the costumes in abstract forms were the work of Alexandra Exter who gave on that occasion the full measure of her talent. This production provided a stylistic example which would nourish the "constructivist" production until almost the end of the twenties. In *Salome*, a skilfully produced lightning made the geometric forms vibrate, giving the impression of floating, while moving on the vertical. The costumes of the actors were the outcome of the ordering of geometric forms. The acting of the players was constrained due to the limits imposed by these forms on their movements. Similar to the scenic version of *Victory over the Sun* in 1913 (the real prototype of this formal sequence), the decoration of *Salome* commanded a strange monumentalization of the dramatic tonality. The new pathetic tone of the "machine age" was born.

Some months earlier, non-objective art had been "on the lines" of the exhibition "Modern Decorative Art," which the Lemercié Gallery presented as usual during the summer. The participation of the

Rodchenko
Linear drawing
1921

suprematists was complete: even Malevich displayed some projects for cushions and bags. Among the suprematists the most noticed were Exter, Rozanova and Davydova. Due to the initiative of the latter a real manufacture of non-objective applied arts was created in the south of Russia.

The only important innovative exhibition to mark the end of 1917 in Moscow was the last "Knave of Diamonds" show. From 16 November to 4 December, one could see the suprematist works of Malevich, Kliun, Rozanova and Davydova in the showrooms of the Bolshaya, Dmitrovka Street. Alexandra Exter had the privilege of a room for herself, where in addition to cubo-futurist and non-objective paintings she showed a large number of theatrical projects and decorative works. This collection acquired the significance of a personal retrospective and was treated as such by the critics. Exter's colourist exuberance was an easy subject for the critics who still refused the geometric severity of Malevichian painting. Only the young critic Roman Jakobson, whose theoretical texts were afterwards to renovate modern linguistics, noticed the pictorial grandeur of the suprematists in characterising Malevich as "the Roman of form [and] intrepid explorer of the world of abstraction searching for new forms for the ferro-concrete soul of the new era."[16]

"The streets are our brushes,
the squares our palettes."
Mayakovsky, 1918

In the month of February, the year 1917 was plunged into the tumult of revolutionary events. The artists left the solitude of their studios to devote themselves to the organisation of the new artistic life. Tatlin, Malevich and Rozanova participated along with the other "futurists,"[17] in the activities of the committees called "of the left." Many "associations" were created, some programmes of teaching and of museum organisations were elaborated in an enthusiastic atmosphere. The insertion of the avant-garde art in society was the fashion of the day. The revolution of October 1917 was to prolong the length of the social tempest: this time, events seemed to

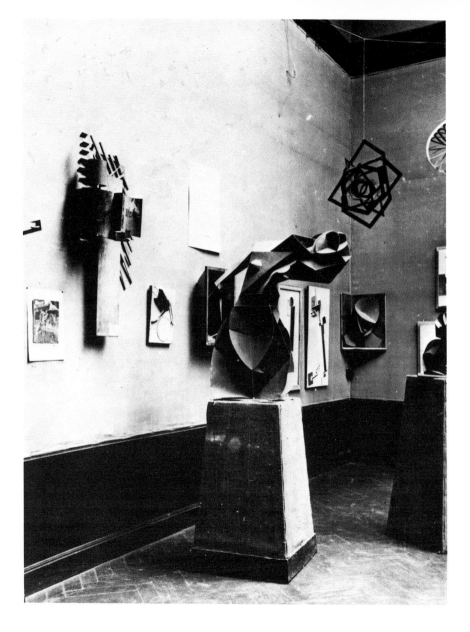

Russian exhibition
Berlin
1922

take a definite and much more radical turn than in February. The destiny of artistic life was taken in hand by a new administration with its inevitable cortège of "commissariats" and "commissioners." At first, the new institutions opened their doors widely to the cubo-futurists and non-objective avant-garde; to such an extent that their enemies spoke of a "dictatorship" of non-objective art. This period of euphoria was to run up quickly against the "snags of life" (Maiakovski). Apart from the opening up of artistic teaching to the problems of modern art, the most important measures taken from the start of the "left wing" committees' activity concerned: 1) the creation of a modern academy which would be named "Institute of Artistic Culture" and 2) the creation of a new chain of museums devoted to the "new pictorial culture." At the beginning of these initiatives Vasily Kandinsky was very actively engaged in the two programmes. A campaign for the purchase of modern works was launched. Aware of the importance of this new institution of museums which gave its letters of recognition to modern art, the Commissariat of Public Education widened the bases of the "new pictorial culture" with the public exhibition of the Shchukin collection. This collection was nationalised and received the title of "First Museum of Western Art." The modernist vogue unfortunately lasted only a short time: during the summer of 1921, with the announcement of the New Economic Policy (NEP), these ambitious programmes slowed down dramatically. The Moscow museum of the "new pictorial culture" was closed for the first time in 1922. Later on, it became an annexe of the Institute of Artistic Culture, and then plunged into obscurity in 1924. The fate of the sister-institution in Petrograd was similar: a consciously entertained ambivalence over the status of this institution handicapped its existence. Finally, it was the old Russian Museum which gathered the remains in order to make them into one of its departments. Similarly, the travelling exhibition of modern art, initiated by the "Museum Fund" in 1919, lasted but one season.

1918 was in any case poor in exhibitions because of great social upheavals and, moreover, because of the disappearance of private galleries which before the revolution assured the material structure of

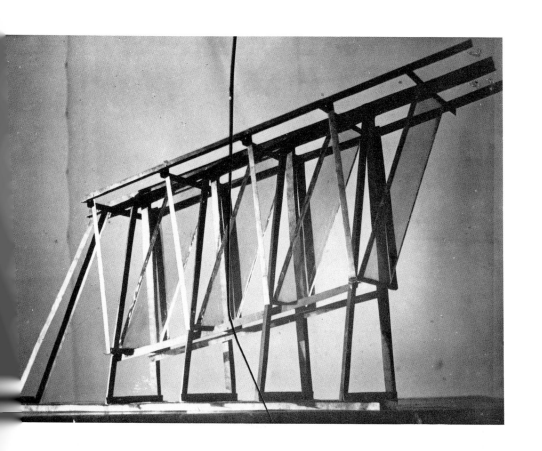

G. Stenberg
Spatial construction N° 13
1921

artistic life. During that same year several large heterogeneous exhibitions were organised in some official halls. Non-objective art found itself completely drowned in these surroundings, as was the case for that enormous "First exhibition of Moscow's professional painters" (May-July 1918): one hundred and eighty painters participated with 741 works, the "freedom to create" implying the non-selective possibility of exhibiting any kind of painting.

The only events that marked artistic life in 1918 were the celebrations which commemorated the first anniversary of the October Revolution. In Petrograd, Meyerhold produced a gigantic representation of Maiakovski's play *Mystery-Buffo* and Malevich was called for the decoration and costumes. Unfortunately, today we have neither photographs of this play, nor even the proposal for the decoration and costumes. Artistic life being emotionally overcharged, the only thing that counted was the exaltation of immediate expression, and this historical play has left as little trace for posterity as did the great popular stagings named "actions of the masses." Destined to commemorate the revolutionary events, these collective psychodramas were applying themselves to install with many symbols a new mythology: the language of non-objective art was closely associated with it in the early period, as proved by the decors of Malevich, Altman (public squares), Vesnin, Popova or Exter (street decorations in Kiev). If one analyses the place occupied by the decorations of Malevich in Petrograd,[18] non-objective art appears in 1918 as the authorised symbol of the new Bolshevik power.

In that autumn of 1918, artistic life recovered an inspiration that revolutionary events interrupted, while giving it a new energy. The first tangible result was to be seen in the opening of renovated artistic schools. The old academy having become obsolete, in Moscow, Petrograd and in other towns "free studios" were organized where the teaching was done by the innovating (plastic) artists, the choice of whom was left to the students themselves. Malevich and Tatlin taught in Moscow.

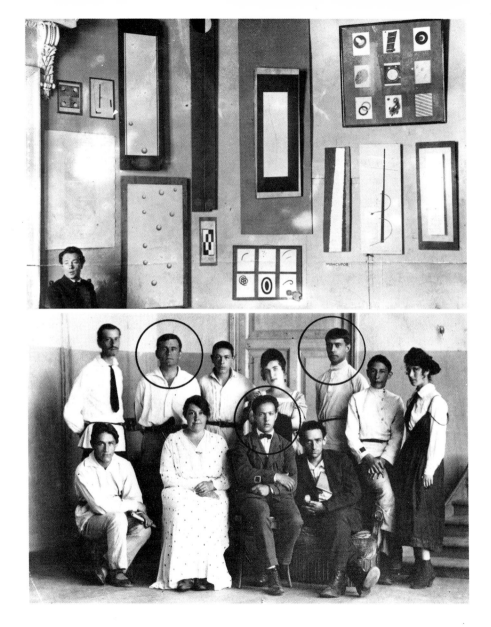

above:
Mansurov, exhibition at Leningrad
1924

below:
the group "Unovis" at Vitebsk
1921

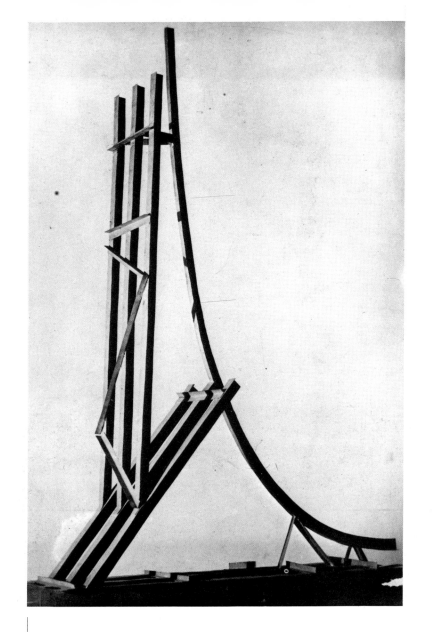

V. Stenberg
Spatial construction N° 4
1921

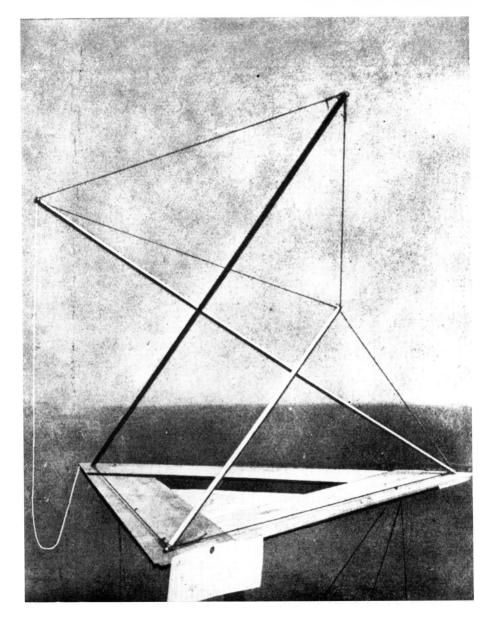

Yoganson
Systematic spatial construction
1921

Another major event marked artistic life towards the end of 1918: on December 7, the first issue of the weekly *The Art of the Commune* appeared at Petrograd. During its short existence, limited to nineteen issues, this journal was to offer a public forum to the avant-garde. It was directed by the critic Nikolai Punin and attracted the collaboration of the best innovative critics (Shklovski), as well as artists like Tatlin, Malevich, the "comfut" (association of "futurist communists.") In the pages of *The Art of the Commune* appeared the texts of the new "productivist" current: osip Brik, Boris Kushner. The brief existence of this avant-garde platform, already liquidated on 19 April, is the proof of the quick changes which mark the epoch. This taking charge of artistic activities by the State generated, on the other hand, new exhibition initiatives. One had never seen as many exhibitions in Moscow as during the years 1919 and 1920. From the beginning of 1919 started a cycle of "State exhibitions" whose goal was the largest possible presentation of all artistic tendencies in the mainstream of the new power. The first of these exhibitions was dedicated to a posthumous commemoration of the work of Olga Rozanova, who passed away suddenly in the autumn of 1918. For the history of modern art it is the "10th" which will count the most. It was named "Non-objective creation and suprematism," a title which already poses a problem, because until this moment, these two terms were synonymous. Nevertheless, in 1919, "non-objective" art was opposed to suprematism; several creators who until 1919 situated themselves in the direct wake of Malevich evoked principles different from his. This exhibition occupies a fundamental place in the brief history of non-objective art, for it constitutes the departure for a kind of "constructivist rupture." Malevich's work and ideas thus became isolated from the mass of "non-objective creation." On this occasion, Malevich reiterated in a "suprematist" manifesto, published in the catalogue, some formulations of his "White Manifesto" (June 1918): the infinity, the ideal domination of white (the pure concept) and absolute creation were considered to be a superseding of man. He was convinced that he was starting a new (cosmic) dimension of thought. Facing him were those who would be later identified under the "constructivist" denomination: Popova, Vesnin, Stepanova and Rodchenko also published declarations in the

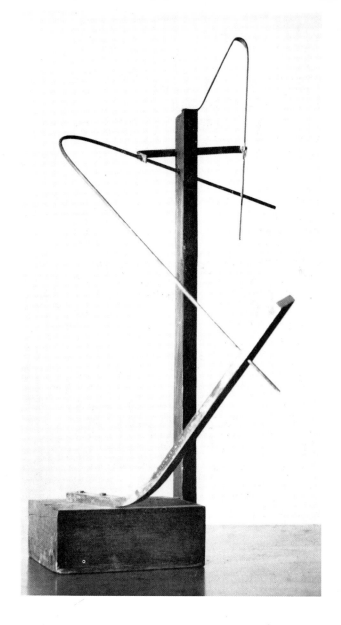

Medunetsky
Construction
1921

catalogue and tried to define their distance from Malevich's "dangerously" metaphysical (white) suprematism. Thus, the evolution of non-objective art, initiated by the "0.10" exhibition of 1915, reached the end of its first great stage. In that year of 1919, they were using all their efforts to counteract Malevich's influence, whose guiding role was openly contested. In opposition to his ideas of an anti-mimetic, autonomous status of non-objective painting, Rodchenko spoke of the "descriptive role of the line."

Faced with this opposition, Malevich's departure from Moscow seemed inevitable; his strong personality had become an obstacle for the present ideology. The one, who, from now on, would be a trouble maker, as he had been in 1915, found himself practically expelled from the constructivist scene. Only the provinces remained for him and it was in the small art school of the town of Vitebsk where he found refuge. On his arrival at Vitebsk in the month of December 1919 began one of the most memorable pedagogic experiences of the time. In the company of a youth free from all artistic prejudices and full of enthusiasm, he put heart and soul into teaching. The only local artist having some professional experiences in non-objective art was E. Lissitzky (1890-1941), who was devoted to non-objective art since his visit to Rozanova's posthumous exhibition. Oriented predominantly towards architecture, Lissitzky became useful in helping Malevich to organize a faculty of architecture which became an integral part of the pedagogic ensemble created by Malevich.

Vitebsk's suprematist group was named "Unovis" (propagators of new forms in art). Malevich's teaching went beyond the realm of painting to venture into pure theory, the applied arts, theatre and architecture. Just as in the other domains, the last was considered, above all on the theoretical level, as "production of (ideal) models." Lissitzky's work of this period offers the best illustration with his projects called "Proun," which the artist himself described as "intermediary stations" between non-objective painting and future architecture. Malevich's pedagogic activity led him to the formulation of new theories: he produced in Vitebsk an important corpus of texts, the elaboration of which would continue throughout the mid-

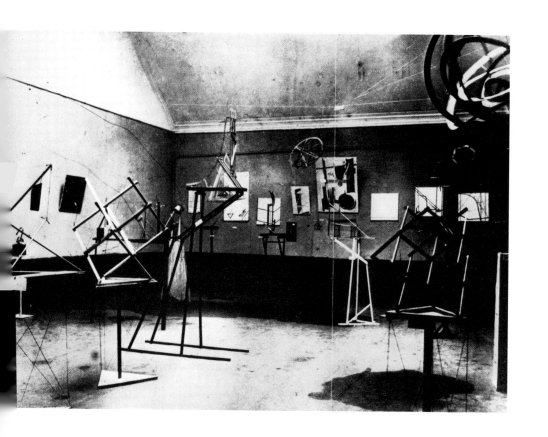

Exhibition of the group "Obmokhu"
Moscow
1921

twenties. Malevich began the theoretical systematisation of the evolution of modern art, its point of departure being Impressionism, and, on the other hand, devoted himself to formulating a "theory of theories" which he called "the theory of the added element." Among his students the most outstanding were Chashnik, Suetin, Ermolaeva, Kogan and—first—Lissitzky. After the closing of the "Unovis" section in Vitebsk in the spring of 1922, they followed Malevich to Petrograd where he was forced to set himself up, as there was no place in Moscow. The choice of Petrograd at that time was tantamount actually to being shelved. Escaping the productivist ascendancy, this erty offered for some brief years the possibility for non-objective art to exist. Deprived of all resources, Malevich held on in the beginning to a post of decorator in a porcelain factory. A little while later, his situation was improved thanks to the organisation of an "Institute of Artistic Culture." While the Muscovite sister-institution was completely submerged by the constructivist-productivist discourse, a climate of tolerance prevailed in Petrograd. Under the name "State Institute" was indeed hidden a small circle composed of some artistic seminars, the two main links being the suprematist group "Unovis" and that of Matiushin called "Zor-Ved."

Supported by Chashnik and Suetin, Malevich continued his analytic work within the framework of a "formal-theoretical section." His attention was directed towards two subjects: a) the elaboration of a general theory of plastic arts and b) the elaboration of a vocabulary of architectural structures. Some architectural models were exhibited in 1923, but more in 1926, when the "Unovis" group organized an exhibition of suprematist architecture in the halls of the Institute of Petrograd.

The "Zor-Ved" group pivoted around Mikhail Matiushin (1861-1934). Musician by training and impassioned editor of futurist texts, he had begun in 1912 the formulation of a strong original theory of pictorial space. Taking off from certain presuppositions of the famous "fourth dimension," he situated man at the centre of a new cosmic image. While taking into account the interaction of the visible and the audible, in his

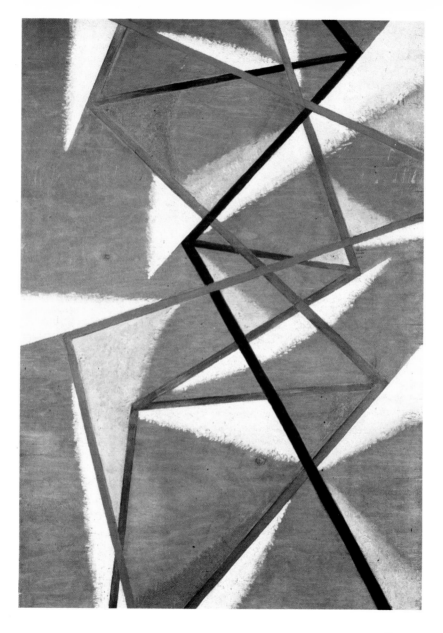

Popova
Construction of lines
1921

plastic system a very special place was reserved for psycho-sensorial sensation. The superseding of the synthesist theories of the symbolists led him to the conception of synthetic images, the formulation of which was carried out with the intermediary of abstract-geometrical images. By attributing a large role to actual experience and to personal imaginary, Matiushin led his students to studying the elementary geometrical forms. Since 1918, his ideas had interested a group of students which was formed around him in the "free studios" of Petrograd. The main members of this group were the Ender family (Boris, Maria, Xenia), who followed him to the Institute of Artistic Culture. The "Zor-Ved" (intense vision) appeared as such in public during the exhibition "All Tendencies" which took place in Petrograd in the spring of 1923. In addition to the pictorial works of the master and his students, Matiushin exhibited on this occasion a three-dimensional piece. This object, in cardboard and metal, entitled "Super-body," constituted the model of a blown-up space, this multi-dimensional space of which he applied himself to studying the properties. Continuing his research on the interaction of sound and the visible, Matiushin formulated at the end of the twenties a remarkable theory of the "interaction of colours." This "open" theory, presupposing a system of infinite variations, was destined to a great future in the domain of architecture in which some of his students would try to channel their creation at the beginning of the thirties.

The Petrograd institute also encompassed for a while the activities of Tatlin's studio. Having officially renounced the "work on the pure form" in a declaration of 21 March 1922, the creator of the reliefs devoted himself at this moment to productivist works. His pedagogic activities were limited to occasional meetings with very few students while he applied himself to the production of ordinary objects (clothes, heating, etc.). After 1924, the meetings of this group stopped. He returned to Moscow where he taught at the art school and worked for the theatre. It was only after the Second World War that on brief occasions he resumed the practice of painting.

Pavel Filonov (1883-1941) was another member of the Institute of Artistic

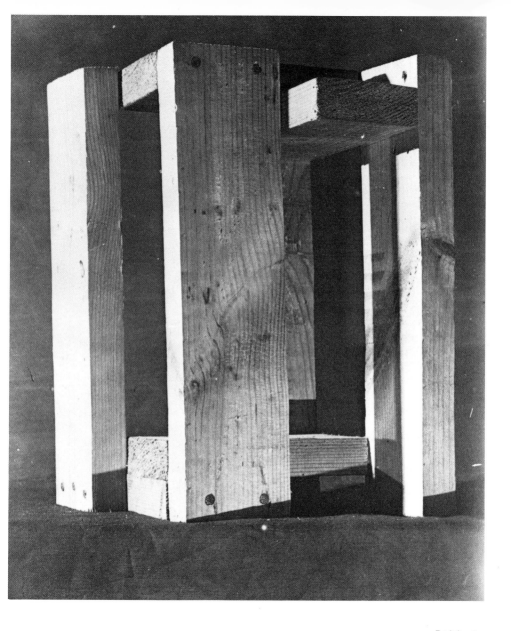

Rodchenko
Systematic construction
1920/1921

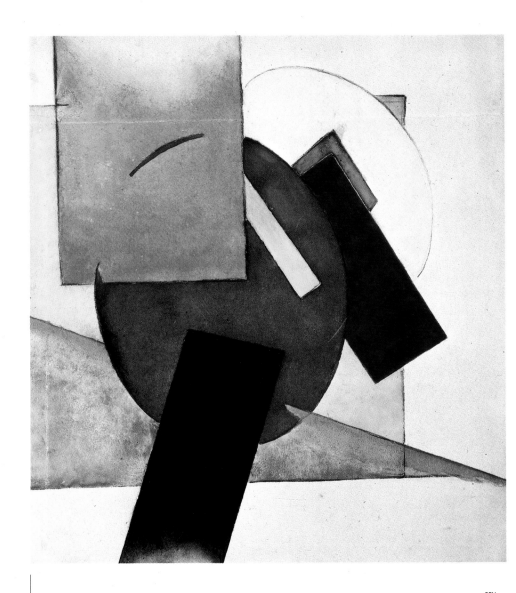

Kliun
Non-objective composition
1920

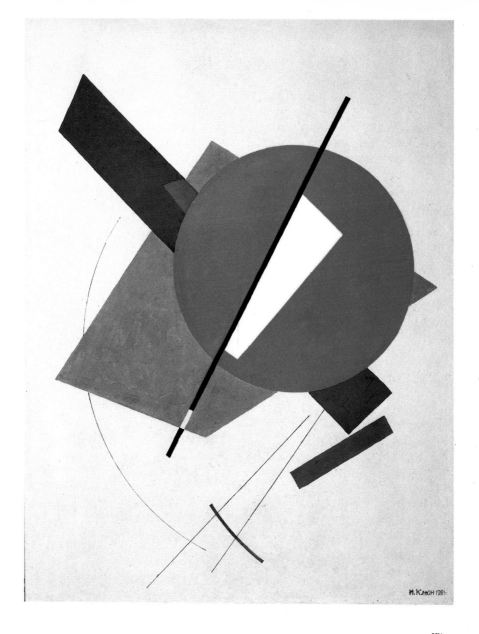

Kliun
Non-objective composition
1921

Culture. His "analytic" group was by far the most coherent and the most ideologically motivated. This painter, who had beginnings during the Cubo-futurist period before the First World War, developed a strong, original theory of "organic form." While using a language of geometric forms, he never left figuration. The novelty of this formal device concerned the principle of composition, based on the strict dependence of each formal segment of the preceding form. He elaborated a kind of labyrinthic principle which led him to abandon the traditional perspectivist conception. His works grow, like wild forests, activated by an extraordinary organic vitality of the formal texture. Verging on "molecular" abstraction and a kind of crystal expressionism typical of the dematerialised-analytic vision of the twenties, Filonov based his formal practice on a truly dogmatic ideological discourse. The inevitable logic of his adherence was to bring about the loss of his art, which was censored at the end of the twenties.

Pavel Mansurov (1896-1983) was the last plastic artist to join the Petrograd institute. The "Section," of which he was the only member, was named "organic culture." Coming to non-objective art only after 1917, this young painter explored nature with a fresh eye. He produced a large number of works which one would qualify today as "ecological": different textural elements are connected with assemblages which very often looked like Kurt Schwitters' works of the English period (1942-1947). Displaying a very subtle pictorial sensibility, Mansurov developed at the same time a formalist painting: refined in its nuances and enhanced by luminist accents which show a great pictorial culture. Having left Russia in 1927, this artist set himself up in France where, for many years, his plastic activities would be limited to decorative art. Beneficiary to a renewal of interest in non-objective art, he took up again his non-objective vocabulary in the early sixties and reconstituted a varied and interesting body of work.

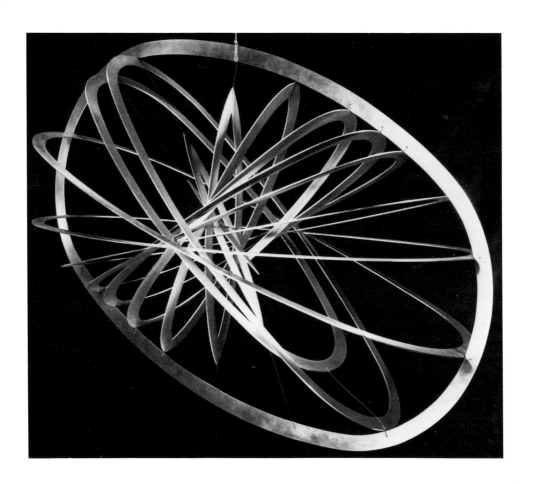

Rodchenko
Suspended construction
1920

"The contemporary constructivist artist is incapable of being anything but an ideologue."
Tarabukin, *From Easel to Machine*, 1923

The transfer of the capital of the new Soviet State from Petrograd to Moscow concentrated all the institutions in that city, thus giving it a focal role in the domain of art as well. The centripetal force of the ideology drew in its wake the theory of plastic arts. Formalism in literature as well as suprematism having been pushed to the periphery (Petrograd, Vitebsk, Smolensk), Moscow saw, in the years 1919-1921, the establishing of a constructivist centre which appeared to be under State protection. From 1918 onwards, some new critics, in favour of materialist postulates, tried to channelise the finality of innovating currents in the direction of an *immediate social utility*.

Non-objective art which had acquired, at the cost of immense sacrifices, a total autonomy in relation to subjects and objects, found itself confronted with the bad conscience of a socially dominant critique. This new critique, while defending the postulates of the so-called "futurist" avant-garde, did not dare to take the risk of unpopularity. It wanted that new art to be liked at all costs. The rapid emergence of non-objective art was too recent and too sudden to have allowed the formation a generation of not only enthusiastic but also strongly motivated critics. While before the advent of non-objective art the new creation came up against the opposition of academic critics, after 1916, and until 1922 non-objective art continued to develop in a kind of critical void. Thus Nikolai Punin remains the best "professional" defender of this art and yet, his articles of that period leave much to be desired! In an article where the demagogic argumentation hits right into the postulates of the non-objective avant-garde, Osip Brik raises the following question: "What does the shoemaker do? He makes shoes. What does the artist do? He does nothing, he creates. This is not clear. It is suspect." Brik was supported in this kind of reflection by other critics like Kushner, Gan and Chuzak. Some titles will give an idea of the

Exter
Costume project for "Romeo and Juliet"
1920

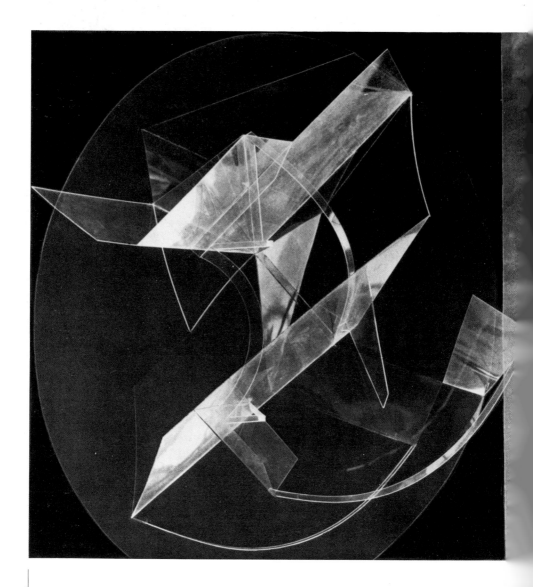

Gabo
Spacial construction C
1921/1922

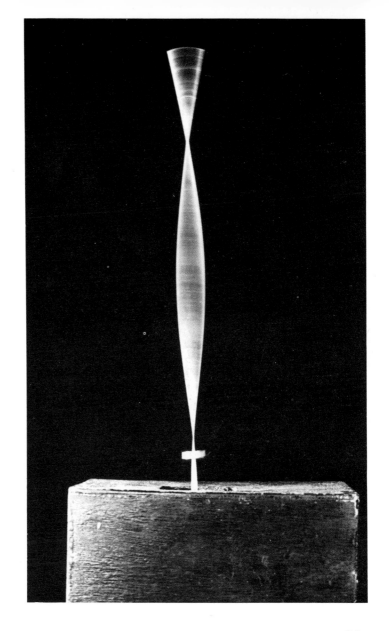

Gabo
Kinetic construction
1920

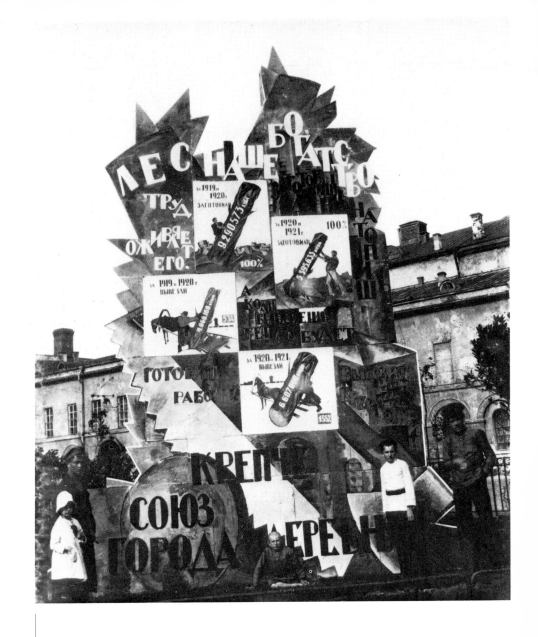

Decoration set up on the Sverdlov Square
Moscow, May 1921

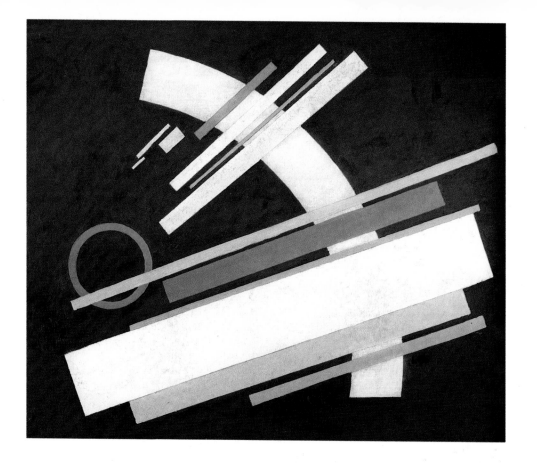

Chashnik
Suprematist composition
circa 1923

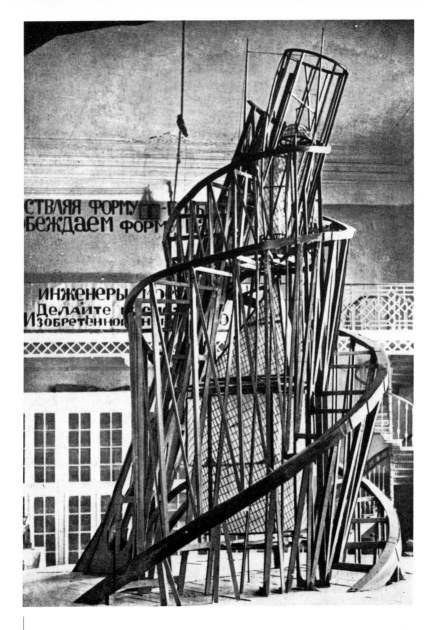

Tatlin
Monument to the IIIrd International
1920

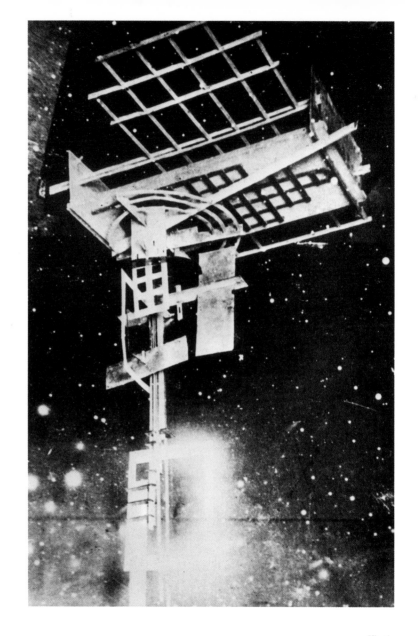

Klucis
Tri-dimensional construction
1920/1922

orientation of this new school: "The factory and the church," "Against the divine work" etc. Public debates were organised around these theses. A new ideological platform was being formed.

It would be naive to imagine that a handful of critics, whose reputation was hardly established, could be capable, thanks only to the support of the authorities of the moment, of reversing the logic went an artistic evolution fiercely attached to autonomy and whose sources go far beyond the immediate actuality. The fight which the cubo-futurists and later on the suprematists had led in the domain of plastic arts and the formalists in that of literary criticism[19] came suddenly into a social void. The innovating currents were not accessible to the proletariat, while the narrow stratum of the enlightened bourgeoisie, among which the avant-garde recruited its sympathisers, was deeply shaken up by the political events. Its fears for the future favoured the emergence of a "scarecrow," in which the innovating postulates of modern art were amalgamated with the image of the new power. Today, the historian can establish that if the Bolshevik power tolerated during a brief period the artistic avant-garde, it was strictly for tactical reasons, because this avant-garde had immediately rallied around the revolutionary slogans, hoping to find in them the materialization of its own artistic utopias. The second and by far the most fundamental cause of the "constructivist" orientation is to be sought in the frustration arising from the lack of a real social dimension of the new art, an alienation which has deeply affected the history of modern art since the romantic period. Its climax is discernible in the open war that, since 1910, the Italian and the Russian futurists declared on social inertia. The artists, suffering for generations from a social rejection, became victims of their own wishful thinking. The fight between the defenders of an art free from all external constraint (Malevich, Filonov, Shklovski) and those of a forced (and immediate) social integration in "production"—this key-word of the twenties—was carried on since the beginning of the year 1919 in the columns of the journal *The Art of the Commune*. It continued later on at the Muscovite Institute of Artistic Culture (1921-1922). During that time, Malevich continued his reflections within the "Unovis" of Vitebsk, but he no

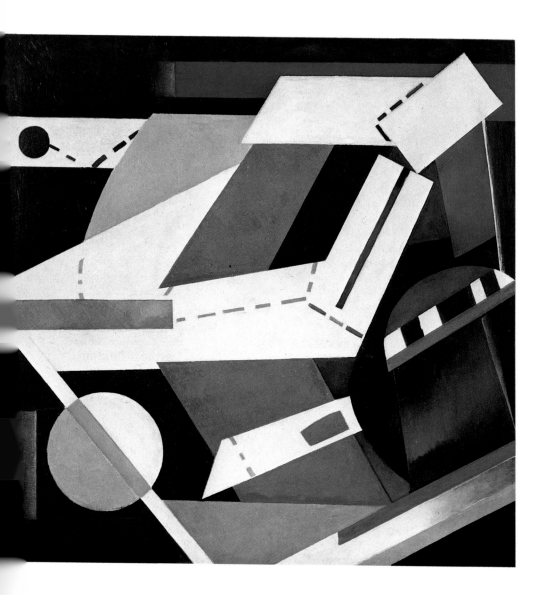

Exter
Construction
1923

longer benefited from having a large audience. His actions were limited only to the Vitebsk-Smolensk region, Moscow keeping him more and more away from the scene of theoretical debates.

"The contemporary aesthetic consciousness extracts the notion of realism from the category of the subject to transport it in the form of the work."
Tarabukin, *From Easel to Machine*, 1923

Tatlin's role in the evolution of the "constructivist" tendency was of prime importance. Commissioned in 1919 by the Education Commissariat for a project of a monument to the IIIrd International, he produced in a Petrograd studio a striking construction whose final dimension would be as audacious as its conception. The project proposed a building of a height of several hundred metres while only a wooden model of about six metres was completed. The particularity of this (habitable) "monument" was constituted by the exhibition of its linear structure (organized in a spiral form) as well as the rotative (perpetual) movement which had to animate this kinetic work: inside the structure were included primary volumes (cube, cone, cylinder) which had to turn at different speeds. They were intended to be occupied by different sections of the IIIrd International, among other things a radio-telegraphic news agency. A symbolic complex of numbers, inscribed in the different systems of rotation, conferred on this project the place occupied formerly by the human image in the cosmology of the Renaissance. The inclusion of the primary forms, besides referring to formal sources of modern art (the famous formulation of Cézanne), gave this monument a synthetic and exemplary significance. The idea of a primary role of agent of communication that art had to play between the "thinking head of the revolution" and the society (what was external to the monument) summed up the message of this work. It crystallised the dream of the avant-garde artists to serve as a unifying agent (factor of communication) of

a society in permanent change. If one adds to the formal grammar of this panorama the dynamic component of perpetual movement included in this gigantic spiral, it is easy to understand the fascination that this project immediately exercised, as well as for future generations, each one seeing itself as a successive link in this ideal chain of a "permanent revolution" (Trotsky).

In May 1919, an exhibition of a "group of young painters" (Obmokhu) took place in Moscow. Apart from "cubist" paintings of poor quality, works "destined for production," projects of decoration, designs and logos were exhibited anonymously. The name of the creator was erased as well as that of the old "artistic will" (Kunstwollen). Everything was drowned out in the battle of words of a violent revolutionary discourse. Social argumentation overruled formal motivation, "aestheticism" was declared a "waste for the human mind." Two years later, these same artists "declared art and its priests outlawed."[20] The Obmokhu association continued to organise its annual exhibitions till 1922. The most remarkable show of this group took place in the month of May 1921. In addition to its regular members Rodchenko and Yoganson participated with an important number of three-dimensional linear structures, some of which are suspended. This participation conferred on the event the rank of a real "constructivist salon." The 1921 exhibition marked the climax of the "lineist" tendency and that of sculptural constructivism.

In January 1922, three members of Obmokhu—the Stenberg brothers and Medunetsky—separately exhibited "spatial apparatus" and some "construction projects": constructivism, put forward in the title of the catalogue, became a style. The rise of the discourse on the social utility of art is discernible since 1920, the year of the establishment of new artistic institutions. At that time were laid down the fundamentals of this new "academy" which wanted to be a research institute and those of a new school of art which carried the name of Higher state Art-Technical Institute (Vkhutemas). In the beginning (until 1922), the programmes of this new school gave priority to the study of the new non-objective art. The teaching

Matiushin
The variation law of the association of
colours
1932

was done by those who had created this art during the years 1915-1920 (Popova, Exter, Rodchenko, Vesnin, Kliun and others). In the basic section, special emphasis was laid on the study of the non-objective vocabulary and on analytic practice. Some practical sections—architecture, work on wood and metal, ceramics, etc.—were organized as well, for this school did not aim to produce artists, but "technicians of production." The Vkhutemas would experience a painful evolution during the twenties, the different stages of transformation of its programme (1922, 1924, 1927) being marked by the gradual elimination of the "basic section," that is, the "abstract" component of teaching. In 1930, the school, or rather the small residue which still existed, was definitively liquidated.

The vicissitudes of the Institute of Artistic Culture resembled those of Vkhutemas. At first, the Commissar of Education, Lunacharsky, entrusted its organisation to Kandinsky. The latter proposed in 1920 several programmes whose common feature was to envisage this Institute as multidisciplinary at all levels. Imbued with the symbolist dream of a "synthesis of the arts," Kandinsky wished to adapt this vision to the period: he envisaged the study of the new language of arts in an interaction with specialists in plastic arts, linguists and musicologists. He thus hoped to lead to the elaboration of a general theory of different artistic languages. The superseding of the strict technicity in every art had to be accomplished in favor of a global theory of the structures of the new artistic language, structures of a *modernity* of which he felt the action at all levels of human expression. However, it was not in this light that the "constructivist" tendency saw the "laboratory" role of modern art. If art was to be considered as a "laboratory," it was not to be the Faustian laboratory of the alchemist-philosopher, but that of the "producer" of the industrial era. It was no longer a matter of producing concepts, but of materially useful objects. Malevich would vainly try to oppose this logic of immediate utility with the postulate that "the only material of work for the plastic artist is pure form."

The rise of the "specific" requirements of the constructivist faction within

the Muscovite Institute of Artistic Culture asserted itself at the beginning of 1921: the constructivist group rejected the Kandinsky programme. Following a series of analytic conferences which seemed to exhaust the discussion on the possibilities of non-objective art, a "productivist" group organised its most striking manifestation — the famous resolution of 24 November 1921 proclaiming the rejection of "pure art." During the brief "analytic" phase of the Institute, the Muscovite Museum of "Pictorial Culture" was attached to this institution. The "retrospective" implication of this association reflected a rather conservative light on the destinies of this association between the past and the future. The first closing of the Museum in 1922 coincided with a serious halt in the activities of the Institute. It would cease definitively to exist in 1924, its members finding themselves forced to reorient themselves in the more traditional domains of academic theory (Academy of the Sciences of Art) or—for the visual artists—in practice and teaching.

The first halt in the activities of the avant-garde, in 1921, motivated an orientation abroad. Artists and works left for Western Europe, in different ways. Today, it is difficult to differentiate between pure and simple immigration (Kandinsky, Gabo) and prolonged stays abroad (Lissitzky, Shklovski and many others). (Pure) non-objective art as well as the constructivist discourse each in its own way crossed the frontiers of Russia. In the spring of 1922, Lissitzky and Ehrenburg published in Berlin the journal *The Object*. This international forum of "productivism" existed barely a few months—those of the production of the only two issues of the journal. In the autumn of the same year, the Van Diemen Gallery presented in Berlin a large panorama of the new plastic currents of Russian art. In this exhibition called "the first Russian show" and organised by the Soviet authorities, one could see for the first time in Western Europe Russian non-objective art in all its diversity: from the suprematist paintings of Malevich and his students, to the most audacious linear constructions of the Muscovite artists. The exhibition at the Van Diemen Gallery marked the beginning of a new period: having lost the reasons for its existence in Russia, non-objective art addressed itself to the western audience and to

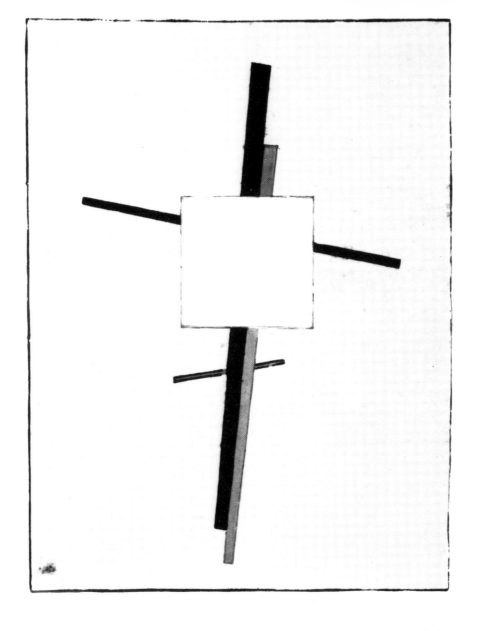

Malevich
Suprematism of the mind
1920

western creators. The teaching of Moholy at the Bauhaus, that of Albers at Black Mountain College and Gabo's activities at the Art Students League in New York were to bear fruit half a century later.

The sad course of the futurist avant-garde and of non-objective art in particular is well known. Throughout the twenties, the discourse on art was confounded with the heavy authority of ideology. The first anti-idealist arguments initiated by Brik in 1918 received in 1922 a doctrinaire formulation in Alexei Gan's pamphlet, *Constructivism*, which tried to reconcile avant-garde postulates with Marxist theory. The denial of the autonomous language of art led, at the end of the twenties, to the disappearance of non-objective art in studio practice. All independent artistic organisations were proscribed in 1932, and this led to the stylistic levelling of all "artistic" production. The doctrine of "socialist realism" was officially proclaimed two years later. Wiping out all the accomplishments of non-objective creation, this doctrine brought plastic arts back to the point of departure of this evolution: the "social realism" of the Russian nineteenth-century realists: the "wanderers" (travelling painters).

"Thought has a universal moment: that which had been well thought will necessarily be thought in another place and by someone else. This certitude accompanies the most solitary and powerless thought."
Adorno, *Remarks on Critical Theory*

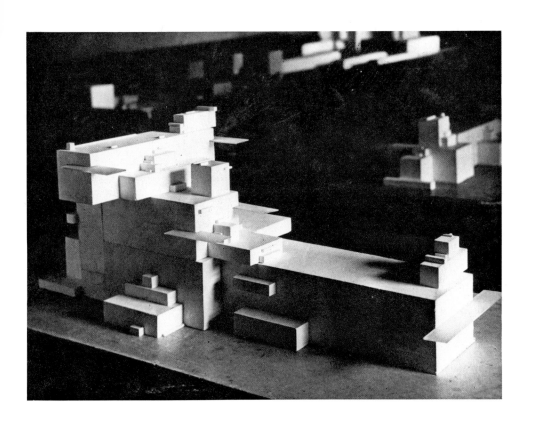

Malevich
Suprematist architectonic
1923

NOTES

1. Since then this painting has been known since under the title *Black Square*, oil on canvas, 79.5 × 79.5, Tretiakov Gallery collection, Moscow. Several later versions of this composition (1924, 1929) have been recently exhibited in Western Europe.

2. The activity of the great Russian collectors of that period has been related *con brio* in the book of Beverly Whitney Kean, *All the empty palaces: the merchant patrons of modern art in pre-revolutionary Russia*, London, Barrie & Jenkins; New York, Universe, 1983.

3. The *Chroniques d'art* of Apollinaire show that in 1912 the possibility of an abstract evolution of cubism was foreseen. The abrupt introduction of "papiers collés" appears in that perspective like a sudden break in that conceptual process and like a come-back to the immediate reality of the object.

4. This subject is developed in my article "Formalisme et trans-rationalité au-delà du cubo-futurisme" in *Change* n°. 26-27 Paris, February 1985, p. 208-238, and especially in my text "La stratification des hérésies", a text which serves as an introduction to Victor Shklovski's volume *"La résurrection du mot."* Éditions Gérard Lebovici, Paris 1985, pp. 9-59.

5. The parents of Malevich (Malewicz) were both of Polish origin. By virtue of his cultural background, he belongs to the two cultures; his texts express this too. Up to 1908, he signed his works in Polish, and reassumed this signature after 1928. The subject is discussed in detail in my German monograph on the artist (to be published by PVA editions, Landau/Stuttgart).

6. It was the "reductivist" approach of the materialist critics of the early twenties in Russia. They wanted to eliminate all metaphysical and purely formal content, to reduce non-objective art to nothing but *the model* of a future production of goods. Their argumentation has been taken up again a-critically during the seventies. Shklovski said in 1921: "They will use our names to oppress the generations to come. That's the way they make canned food" (in *The jump of the horse*)

7. This series of drawings is preserved at the Central State Archives of Art and Literature (CGALI), Moscow. Some of them were exhibited in 1977 in Moscow, during the "Vladimir Tatlin" retrospective.

8. It was published in Russian in Berlin.

9. See my explanations in the "Introduction" to *Malévitch, Écrits,* Éditions Champ Libre, Paris, 1975 and enlarged Italian edition Feltrinelli, Milan 1977.

10. I am referring to the titles as given by the artist in the catalogue of the exhibition "Non-objective creation and suprematism," Moscow, 1919.

11. Ref. the series of "Departures," collection of the Museum of Modern Art, New York.

12. Text included in the catalogue of the exhibition "5 × 5 = 25," Moscow, September 1921.

13. Nikolai Roslavets (1880-1944) was a childhood friend of Malevich. After 1915, he adopted the technique of dodecaphonic writing. He was the defender and the introducer of Arnold Schönberg's work in Russia.

14. A version of this text was published in 1919 in the pages of the anthology *Izobrazitel'noe isskustvo* (Visual Art).

15. In his 1915 *Manifesto*, Malevich said: "The (pictorial) construction does not stem from the relations between the forms and the colour."

16. Article published in *Gazeta futuristov* (the Journal of the Futurists) n° 1 (and only one), Moscow, 18 March 1918.

17. By 1917, this denomination had acquired a social and no longer a stylistic character.

18. In particular, his decoration for the conference on "Peasant poverty." This meeting of the "Soviet" peasants was held in the autumn of 1918 at Petrograd's Winter Palace.

19. One must not forget that modern linguistics originated from a reflection on futurist poetry, the latter being itself closely associated with the evolution of plastic arts.

20. A manifesto reproduced in A. Nakov, *2 Stenberg 2*, Paris-London, 1975, p. 66.

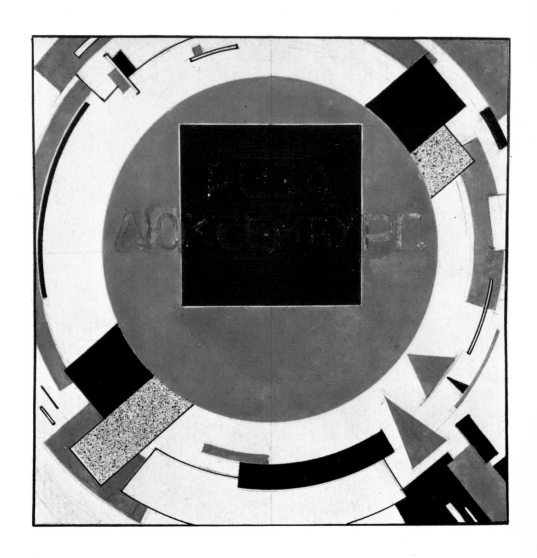

Lissitzky
Proun
1919/1920

Lissitzky
Cover for "Architektura Vhutemas"
1928

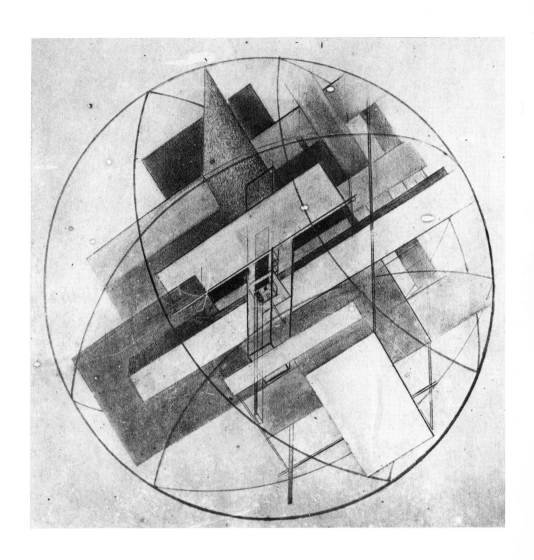

Klucis
Spherical construction
1921/1922

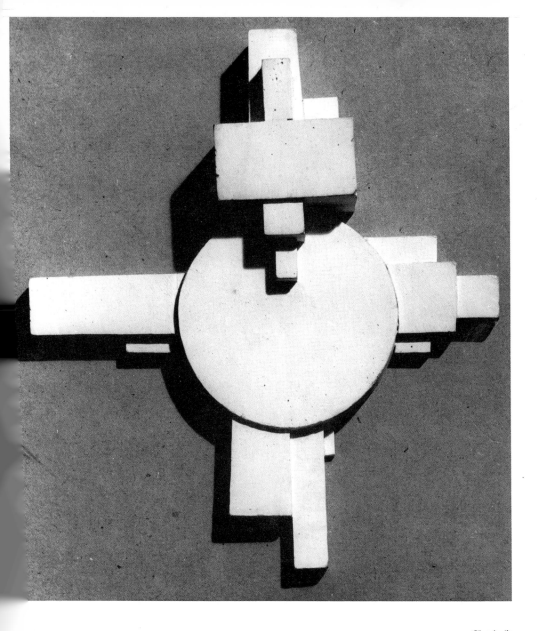

Chashnik
Architectonic relief
circa 1926

There is, today, a proliferation of literature on the Russian avant-garde, a subject which has attracted a great deal of attention since the end of the sixties, and knowledge of which has been enriched especially in the years 1972-1981.

1. GENERAL WORKS

C. Gray, *The Great Experiment: Russian Art 1893-1922*, London-New York, 1962. Outdated on certain points and corrected in numerous details, this book still offers the most lively introduction to the subject.

V. Markov, *Russian Futurism: A History*, Berkeley and Los Angeles, 1968. Fundamental work, with an excellent documentation.

A. Nakov, *Abstrait/Concret. Art non-objectif russe et polonais.* Transédition, Paris, 1981. A text which synthethizes the evolution of Russian non-objective art from 1918 until the end of the thirties, including its reflections and confrontations outside of Russia (the Ukraine, Poland, Germany).

C. Lodder, *Russian Constructivism*, Yale University Press, London, 1983. This work brings together in one volume a Soviet and Western documentation, dispersed up to now in different specialised sources, without however proposing a differentiation of themes and subjects.

Since the memorable Berlin exhibition *Ost-Europa Avant-garde* (Akademie der Künste, 1967), several exhibitions have been devoted to the Russian avant-garde. Some catalogues issued then offer valuable documentation. The rich catalogue of the XVth Exhibition of the European Council, *Tendenzen der Zwanziger Jahre*, Berlin 1977, presents the best synthesis of the subject, mostly within a confrontation with Western abstract art and the other innovating currents of European art (Dada, Surrealism, etc.) While being drawn into the confusions of styles and tendencies, the *Paris-Moscow* catalogue, Centre Georges Pompidou, Paris 1979, provides a very useful documentation.

Stephanie Baron and Maurice Tuchman, *The Avant-Garde in Russia, 1910-1930: New Perspectives*, exhibition catalogue Los Angeles County Museum of Art, Los Angeles, 1980. This publication, very popular in the U.S.A., contains factual lacunas and several misleading attributions to be used with precaution by the uninformed reader.

Also worthy of consultation are the bilingual catalogues (German-English) of the Gallery Gmurzynska of Cologne: *Von der Fläsche zum Raum*, 1974; *Die Kunstismen im Russland*, 1977; *Kunstlerinnen der russischen Avant-Garde*, 1979 and *Von der Malerei zum Design*, 1981, as well as those of the Annely Juda Gallery, London (also bilingual French-English): *Russian Pioneers*, 1976; *The Suprematist Straight Line*, 1977; *The First Russian Show*, 1983;

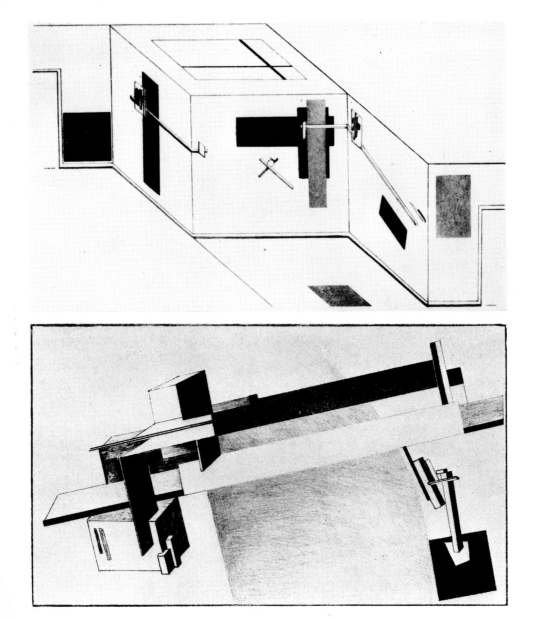

above: Lissitzky
Proun Space, 1923

below: Proun 1 A, 1929

Dada and Constructivism, 1984.
A very rich iconographic documentation is provided in A. Rudenstine, ed., *The George Costakis Collection, Russian Avant-Garde Art*, New York, London, 1981.

2. TEXTS OF THE PERIOD
John E. Bowlt, ed. *Russian Art of the Avant-Garde: Theory and Criticism*, New York, 1976.
Troels Andersen and Ksenia Grigorieva, ed., *Art et poésie russes 1900-1930* (anthology of texts in French translation), Centre Georges Pompidou, Paris, 1979.
Nikolaï Tarabukin, *Le Dernier Tableau* (writings on art and the history of art at the time of Russian constructivism, presented by Andrei B. Nakov), Editions Champ Libre, Paris 1972.
Among the texts of the artists, those of Malevich occupy a choice place due to their theoretical and socio-cultural importance. An English translation in four volumes, published from 1968 onwards in Copenhagen (T. Andersen, ed.), is available. There are also two French translations: a) Editions l'Age d'Homme of Lausanne (several volumes from 1974 onwards, edit. J.-C. Marcadé): b) Editions Champ Libre: *Malévitch Écrits* (ed. A. Nakov), Paris, 1975, a new revised edition will be published in 1986. Given the abundance of Malevich's texts, these publications do not encompass the totality of his theoretical production.

3. MONOGRAPHS
For Malevich, the catalogue of the Stedelijk Museum's Collection in Amsterdam, published in 1970 by T. Andersen, is useful. L. Schadowa's book, *Suche und Experiment-Russische und Sowjetische Kunst 1910 bis 1930,* Dresden, 1978 (English translation, Thames and Hudson, London, 1983) takes up the Soviet point of view on the subject with the inevitable materialist-productivist deformation of the suprematism's theses, presented in the perspective of the "design."
The best introduction to Tatlin's work is to be found in the catalogue of his only Western exhibition at the Moderna Museet, Stockholm.
Ref. T. Anderson, ed., *Vladimir Tatlin,* Stockholm, 1968. The iconography of this documentation would require some corrections to remain up to date. The John Milner essay, *Vladimir Tatlin and the Russian Avant-Garde*, Yale University Press, New Haven and London, 1983, indudes an iconographical supplement not always beyond reproach. A Soviet anthology on Tatlin has been published in Hungarian by Corvina Press, Budapest, 1984. An English version is currently in preparation.

RODCHENKO
German Karginov, *Rodtchenko*, in Hungarian, Budapest, 1975 (French translation, Editions du Chêne, Paris, 1977).

Rodchenko, exhibition catalogue, Museum of Modern Art, Oxford, 1980 and *Alexander Rodtchenko,* exhibition catalogue Kunsthalle Baden-Baden, 1983. There are also several publications on the photographic activity of the artist. Ref. in French language *Rodtchenko photographe,* exhibition catalogue written by A. Nakov, Musée d'Art moderne de la ville de Paris, 1977.

ON THE OTHER ARTISTS
Sophie Lissitzky-Küppers, *El Lissitzky, Life, Letters, Texts,* Intro. by Herbert Read, Dresden and London, 1967.
Herman Berninger and Jean-Albert Cartier, *Pougny. Catalogue de l'œuvre.*t.l, *Les Années d'avant-garde, Russie-Berlin* 1910-1923, Tübingen, 1972.
A. Nakov, *Alexandra Exter,* Paris, 1972.
A. Nakov, *2 Stenberg 2.* The "Laboratory" Period (1919-1921) of Russian Constructivism, Paris, London and Toronto, 1975.
Tschaschnik, exhibition catalogue, Kunstmuseum, Düsseldorf, 1978.
Also *Chashnik,* Leonard Hutton Galleries, New York, 1979.
The fields of Russian formalism and futurism have been thoroughly researched in the last few years by American Slavic students. Their specialized publications are mainly published by Ardis Press, Ann Arbor, Michigan.

1913
3 and 5 December, Petrograd. Public presentation of the "futurist opera" *Victory over the sun,* text by Kruchenykh and Khlebnikov, music by Matiushin, costumes and decorations by Malevich. First apparition —"unconscious" Malevich will say later on—of non-objective forms, including the *Black Square.*
1914
10-14 May, Moscow. Tatlin exhibits in his studio the first non-objective reliefs. On the poster announcing the exhibition, these sculptures of cubo-futurist inspiration are described as "synthetico-static" compositions.
1915
March, Petrograd. At the first futurist exhibition "Tramway V," Tatlin presents seven "pictorial reliefs." Malevich participates with eighteen paintings, of which five are "trans-rational" works, the author indicating in the catalogue "to ignore their content." Exter, Rozanova, Popova, Udaltsova, Puni and Morgunov participate with cubo-futurist works.
June. Malevich paints in Moscow the first non-objective canvasses. They will remain unknown to the other artists until autumn.
On 19 December in Petrograd, is the opening of the "Last futurist exhibition: 0.10." Malevich presents thirthy-nine non-objective paintings and distributes his booklet *From cubism and futurism to suprematism. A new pictorial realism.* A "suprematist" manifesto carries the signatures of Malevich, Kliun, Puni and of the wife of the latter. Tatlin participates at the exhibition with thirteen works, including two large "angular reliefs." He

publishes a biographical leaflet in which four reliefs are reproduced. Rozanova, Kliun and Puni also present non-objective reliefs.

1916

January, Moscow. Rozanova realises the first series of twelve abstract collages which constitute the illustrations of the text *The universal war* by the poet Kruchenykh.

March, Moscow. Tatlin presents the "Futurist exhibition Magasin." Malevich, Kliun, Popova, Udaltsova and Morgunov participate only with cubo-futurist works, while Tatlin shows "pictorial and angular reliefs." The first participation of Rodchenko at an avant-garde exhibition with figurative works and abstract-geometrical drawings, "realised with the help of the compass and ruler."

November. Moscow. Exhibition of the group "The Knave of Diamonds," of which Malevich becomes the president. Massive exhibition of non-objective paintings by Malevich (60 works), Kliun, Popova, Rozanova, Udaltsova, Exter.

Moscow. Taïrov stages at the Chamber Theatre *Thamire the Citharœdus* of Annensky. One notices above all the geometric decor of Alexandra Exter.

1917

February. From the beginning of the revolution, the leaders of the avant-garde —Tatlin and Malevich in particular— participate in the organization of the new artistic institutions.

Moscow. On 9 October is the showing of the play *Salome*, by Oscar Wilde. Staged by Taïrov, suprematist decoration by Alexandra Exter.

The group "Knave of Diamonds" (new version) presents its last exhibition: non-objective works of the Malevichian circle "Supremus" (Malevich, Popova, Udaltsova, Rozanova, Kliun, Exter).

1918

Moscow. On 15 June, Malevich writes his *White Manifesto*. The "Supremus" group is dislocated.

Death of Rozanova.

First personal exhibition of Rodchenko at the Moscow club of the young artists.

December, Petrograd. Beginning of the publication of the weekly *The Art of the Commune*, whose editor is the critic Punin. Malevich, Shklovski, Brik, Kushner and others participate in it. The existence of this "committed" and pro-constructivist publication stopped in April 1919.

1919

Moscow. Posthumous exhibition of Olga Rozanova.

Moscow. "Non-objective creation and suprematism" exhibition. Participants are: Malevich, Popova, Vesnin, Kliun, Rodchenko, Stepanova, Rozanova (posthumously). Rodchenko presents a large number of works including his compositions "black on black" that are facing Malevich's "white on white." The latter is attacked in the catalogue by his former comrades.

During the summer, Malevich announces giving up his pictorial practice and declares devoting himself to theory ("pure non-objectivity"), which leads to the "anti-pictorial" reaction of Rodchenko and the beginning of the "lineist" style.

Malevich and Tatlin teach at the "Free Studios" of Moscow. At the "XIX State

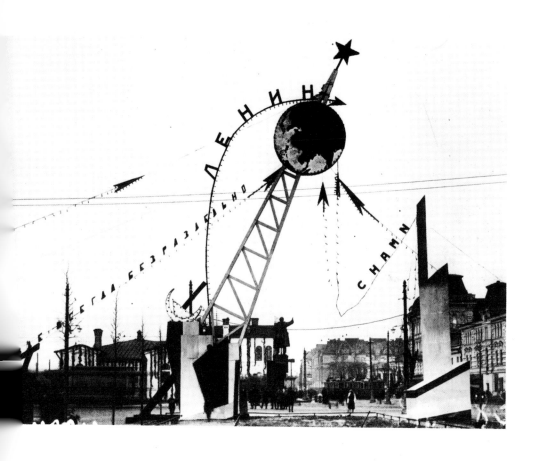

Decoration set up in front of the Finland
Station
Leningrad, 1927

Exhibition," Rodchenko presents a large number of paintings that look like a personal retrospective (the only one during his life).

November, Vitebsk. Malevich begins his teaching at the Art School. Formation of the suprematist group "Unovis." Publication of Malevich's text *New Systems in Art*.

1920

January, Moscow. Large personal retrospective of Malevich. Without catalogue. Malevich publishes in Moscow the brochure *From Cézanne to Suprematism* and at Vitebsk the selection of lithographs, *Suprematism: 34 drawings*.

May. Conferences of Malevich in Moscow and Smolensk. Creation in Smolensk of a branch of "Unovis" of which director is the painter Strzeminski who was a former student of Tatlin in Moscow.

Moscow. Creation of the "Institute of Artistic Culture" of which the organization is given, at first, to V. Kandinsky. He thinks out the programmes of a "Pluridisciplinary Academy" with a humanist and theorical profile.

On 5 August, Naum Gabo and his brother Antoine Pevsner publish in the form of a poster a "Realistic Manifesto;" it accompanies their outdoor exhibition, in the middle of the circular boulevards of Moscow. Gustav Klutsis (student of Malevich and of Pevsner) also participates in this exhibition. All the bi-and tri-dimensional works are of post-cubist nature.

Winter. Tatlin presents the model of a "monument to the IIIrd Communist International." This project provokes a large interest and public debates.

Moscow. Creation of a new art school named "State Art Technical Institute" (Vkhutemas).

1921

Moscow. The Kandinsky programme is rejected by the "left-wing" faction of the Institute of Artistic Culture which, from the beginning of the year 1921, falls into the "constructivist" camp.

February, Berlin. Ivan Puni presents some suprematist works within his personal exhibition at the Gallery "Der Sturm."

Rodchenko writes his text on "The line," which serves as manifesto.

May. Exhibition of the group of "young painters" ("Obmokhu"). Non-objective constructions of V. and G. Stenberg, Medunetsky, Yoganson, as well as suspended sculptures of Rodchenko are presented.

Summer. Announcement of the New Economic Policy (NEP) by Lenin. Halt of the avant-garde activities.

September. Rodchenko, Stepanova, Popova, Vesnin and Exter organise the constructivist exhibition "5 × 5 = 25." It takes place at the "Poets' Club" and is accompanied only by a roneoed catalogue. On this occasion, Rodchenko "asserts the three pure colours: blue, yellow and red."

The critic Tarabukin reads, within the Institute of Artistic Culture, the paper "The last picture has been painted," a text which constitutes one of the first and most relevant interpretations of the evolution of Russian non-objective art.

On 24 November, twenty-five painters declare "giving up painting." They vote at the Inkhuk a resolution proposed by the

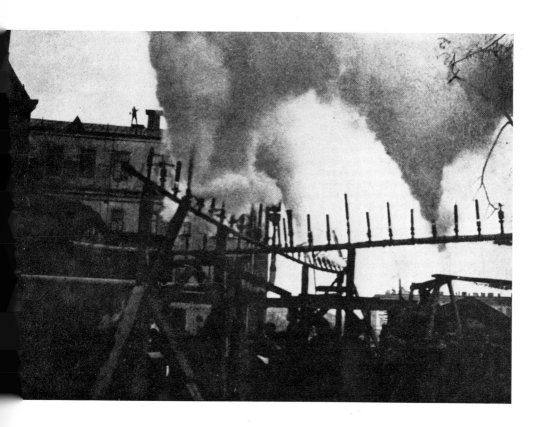

Concert of factory sirens
circa 1920

"productivist" critic Osip Brik: they assert "giving up the creation of pure forms to devote themselves only to the 'production' of models of useful objects."
Several non-objective artists emigrate to Western Europe.

1922

January, Moscow. Exhibition of the "Constructivist" group: V. and G. Stenberg and K. Medunetsky. Some "spatial apparatus" and some "bi-dimensional constructions" are presented
April. Malevich publishes in Vitebsk the booklet *God has not been cast down*. Closing of his Suprematist Section at the Art School of Vitebsk. Having tried in vain to find a job at Moscow, he moves to Petrograd where he is followed by his best students: Suetin, Chashnik, Khidekel, Yudin, Ermolaeva, Kogan.
April, Moscow. Meyerhold presents the play *The Magnificent Cuckold* of Crommelynck with Popova's constructivist decorations.
May, Berlin. Lissitzky participates in the "Grosse berliner Kunstausstellung" with six works, of which four are (suprematist) "Prouns." With Ehrenburg, he begins the publication of the international journal *Vesc-Objet-Gegenstand*, of which they will realize only two issues.
November, Moscow. Meyerhold presents the play *The Death of Tarelkine* by Sukhovo-Kobylin with Stepanova's constructivist decorations.
November, Berlin. The Van Diemen Gallery organizes the "First Russian exhibition." One can see for the first time in Western Europe suprematist works (Malevich and his students of the "Unovis," Lissitzky, Exter, Rozanova) and constructivist works (Tatlin, Rodchenko, Gabo, Pevsner, Stenberg, Klutsis, Medunetsky and others). The same Exhibition will be presented at beginning of the year 1923 at the Amsterdam's Stedelijk Museum.

1923

23 March, Paris. During the tour of the Taïrov theatre, the Paul Guillaume gallery presents for a day an "Exhibition of miniatures of the Chamber Theatre of Moscow" where appear the non-objective constructions of the Stenberg brothers and of Medunetsky. Spring, Petrograd. An "Institute of Artistic Culture" (Ginkhuk) is founded: the sections are directed by Malevich, Tatlin, Filonov, Matiushin and Mansurov. The critic Punin becomes the "scientific secretary."
May. "All tendencies" exhibition with the participation of the groups of Malevich ("Unovis,") Matiushin ("Zor-Ved,") Tatlin, Filonov and others. The coverage of the press is negative.
May, Berlin. Lissitzky realizes within the "Grosse berliner Kunstausstellung" the first non-objective tri-dimensional space "Proun."

1924

Moscow. Popova's posthumous exhibition.
Venice. "XIVth International Exhibition of the City of Venice" (Biennale). The Soviet hall contains, among others, non-objective works of Malevich, Rodchenko, Popova and Exter. However, they attract no attention.
Paris, Percier Gallery. Exhibition of the "Russian constructivists" Gabo and Pevsner.
Vienna. "International exhibition of

ILLUSTRATIONS

theatrical techniques" organized by Kiesler. Important Russian participation.
1925
Dresden. Personal exhibition of El Lissitzky at the Kühl und Kühn Gallery.
Paris. "International exhibition of modern decorative Arts." The Soviet section includes separated presentations on theatre, architecture, applied arts, typography and artistic teaching. The architecture of the hall is by Melnikov. A "reading club for workers" is realized by Rodchenko in one of the rooms of the hall.
1926
Leningrad. Last presentation of the activity of the Institute of Artistic Culture. The "Unovis" group (Malevich) presents architectonic projects in three dimensions. He is violently attacked by the press. Closing of the Ginkhuk of Leningrad.
1927
Summer, Warsaw and Berlin. First Malevich retrospective outside the USSR. The painter returns to Leningrad leaving in Germany the works of the exhibition and and important selection of his personal archives. The Bauhaus editions publish his book *Die gegenstandslose Welt*.
Hanover. At the Landesmuseum Lissitzky realizes the permanent installation of an "Abstract Cabinet."

83 : Rodchenko. *Suspended construction*, 1920, wood, 52 × 85 × 46 cm. Documents of Alfred Barr Archives, New York.

85 : Exter, costume project for "Romeo and Juliet" December, 1920, gouache on cardboard, 52 × 38 cm, private collection, Paris.

86 : Gabo. *Spacial construction C*, 1921-1922, dimensions unknown, destroyed work. Documentary photograph, Katherine Dreyer. Archives, Yale University Art Gallery, U.S.A.

87 : Gabo. *Kinetic construction*, 1920, mobile sculpture: iron wire put into motion by an electric motor, destroyed. Documentary photograph and reconstruction, Tate Gallery, London.

88 : Decoration set up on the Sverdlov Square in Moscow, for the 1 May celebrations of 1921.

89 : Chashnik. *Suprematist composition*, c. 1923, oil/canvas, 70 × 84 cm, Modernism Gallery, San Francisco.

90 : Tatlin. Project for the *Monument to the IIIrd International*, wood, Petrograd 1920. Destroyed.

91 : Klutsis. *Tri-dimensional construction*, 1920, 1922, cardboard project, glass and plywood, dimensions unknown. Lost work and probably destroyed. Documentary photograph, Archives Nakov, Paris.

93 : Exter. *Construction*, 1923, oil/canvas, 96 × 96 cm, McCrory Corporation collection, New York.

96 : Matiushin. *The variation law of the association of colours*, Leningrad, 1932, gouache on paper, each unit 12.5 × 17.5 cm. Document of Archives Nakov, Paris.

99 : Malevich. *Suprematism of the mind*, 1920, illustration included in the booklet *Unovis n° 1*, gouache lithograph, 35.5 × 25.5 cm, private collection, USSR.

101 : Malevich. *Suprematist architectonic*, 1923, dimensions unknown. Document of the journal De Stijl, 1927, N. 79-84.

104 : Lissitzky. *Planetary suprematism*, 1919-1920, gouache on paper, 10 × 10 cm. Costakis collection, Athens.

105 : Lissitzky. Cover for the booklet *Architektura Vkhutemas*, Moscow 1928. Document of Archives Nakov, Paris.

106 : Klucis. *Spherical construction*, 1920-1922, documentary photograph.

107 : Chashnik. *Arthitectonic relief*, ca. 1926, plaster, 16.4 × 18.7 × 2.6 cm, Leonard Hutton Galleries, New York.

109 : Lissitzky. Above: *Prounenraum/Proun Space*, 1923. Lithograph, 43.5 × 60.5 cm. Kupferstichkabinet, Berlin. Below: *Proun 1 A*, 1919, lithograph, 34.5 × 45.5 cm, Kupferstichkabinet, Berlin.

113 : Decoration set up on the square of the Finland Station at Leningrad, on 7 November 1927.

115 : Concert of factory sirens, c. 1920.

Cover:
Front: Lissitzky, *Proun 12 E*, 1920, oil on canvas, 57 × 42.5 cm, Bush-Reisinger Museum, Harvard University, U.S.A.
Back: Still from the film, *Aelita*, 1923, decor by Exter, document of Cinémathèque nationale, Paris.